MW00769799

Understanding
PERSPECTIVE

BARRON'S

Designed and produced by Parramon Paidotribo

Editorial Director: María Fernanda Canal
Editor: Mari Carmen Ramos
Text: Gabriel Martín Roig
Exercises: Gabriel Martín and Merche Gaspar
Corrections: Roser Pérez
Collection Design: Toni Inglès
Photography: Estudi Nos & Soto
Layout: Estudi Toni Inglès

Original title of the book in Spanish:
Miniguías Parramón—Comprender la perspectiva
© Copyright 2013 ParramonPaidotribo–World Rights
Published by Parramon Paidotribo, S.L., Badalona, Spain

Production: Sagrafic, S.L.

Translated from the Spanish by
Michael Brunelle and Beatriz Cortabarria.

First edition for the United States, its territories
and dependencies, and Canada, published 2014
by Barron's Educational Series, Inc.
English edition © 2014 by Barron's Educational
Series, Inc.

All rights reserved.
No part of this publication may be reproduced or
distributed in any form or by any means without
the written permission of the copyright owner.

All inquiries should be addressed to:
Barron's Educational Series, Inc.
250 Wireless Boulevard
Hauppauge, New York 11788
www.barronsedu.com

ISBN: 978-0-7641-6583-2

Library of Congress Control Number:
2012948369

Printed in China
9 8 7 6 5 4 3 2 1

Understanding
PERSPECTIVE

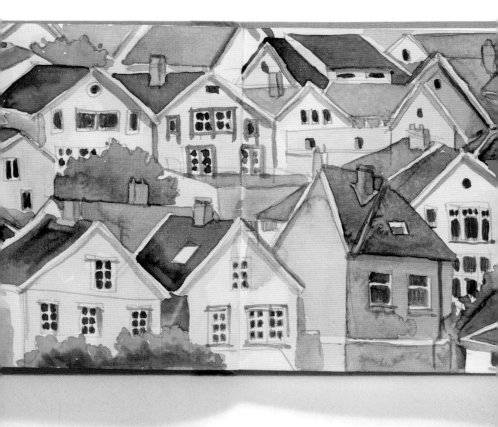

Contents

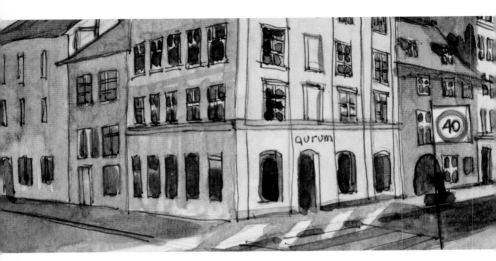

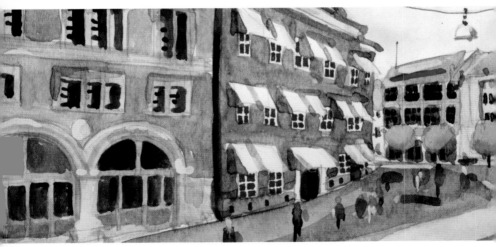

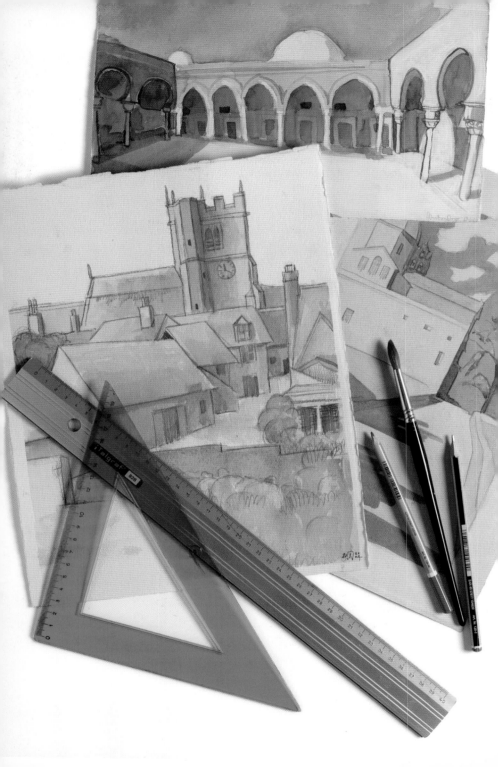

Perspective: Law and Order

Perspective does not exist! This statement may seem a categorical and contradictory way to begin the introduction to a book about perspective, but after this brief explanation you will see that it is not.

Perspective is defined as the art of correctly representing the forms of objects and the way they are deformed as they become more distant, a methodology that is based on a geometric system for representing three dimensions on a flat surface with two dimensions. It is a simulation of what can be seen in nature, which allows you to calculate the effect on the volume of objects that are in turn placed in an environment of falsified depth.

Yes, falsified. Linear perspective does not correspond to the natural way of seeing things; it is an abstraction, a cultural elaboration that has been passed down through history through various stages of development before adapting its present form. Try projecting the lines of perspective on a photograph of a street seen in perspective, and you will see that not all lines converge at the same point; there are small differences. This small experiment is an attempt to show that mathematical perspective does not exactly match the real model; however, despite the maladjustments, it is clear that it does help in coherently representing space.

Therefore, despite the fact that it is an invention, a re-creation, or a mathematical convention, perspective is the system that best explains distance based on the diminishing sizes of objects and the angle of convergence of the lines at one or several imaginary points located on the horizon line. The sensation of depth is pure illusion, but it forms part of a very effective technique of projecting diagonal lines. The laws of perspective strive for truth in the relationship between the drawing and the model using systems that create the illusion of depth on the paper, in a way that the viewer can deduce the real distances between the objects.

Its use is indispensable for all artists since it creates a better understanding of the model by showing a necessary sense of depth, of the space going back. But you must differentiate between the technical approach and the artistic approach, since the latter is the truly interesting one. Artistic perspective is not based on numbers and precise measures and mathematics; the rules are applied to painting and drawing so that the objects represented in the scenes maintain a coherent spatial relationship—so that those that are farthest away in reality look like they are the farthest away in the painting, and the closest ones look like they are near. There is no need to be exact; it is enough if they look convincing.

This book hopes to make you familiar with the purpose and the reasons for perspective as it is applied to drawing and painting, and the rules it follows. Therefore, we offer some basic ideas about perspective and some guidelines for its practical application.

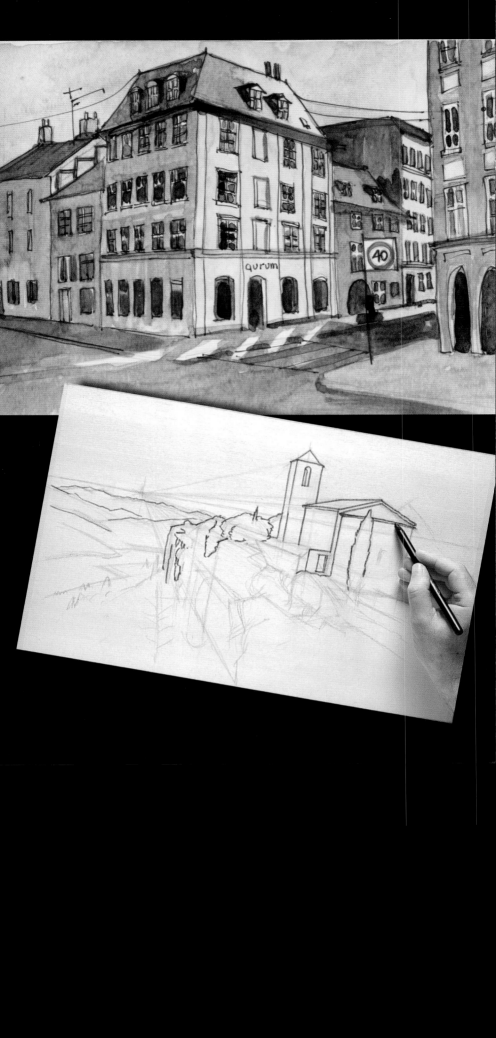

Basic
Perspective

Thanks to geometry—that is, to the straight lines drawn with a square, a triangle, or freehand (if your hand is steady)—the visual effect of perspective can be simulated by projecting three-dimensional objects on a plane, on diagonal lines that converge at one or several points that are lost in the distance. A perspective drawing attempts to facilitate the artist's work by controlling the variation between the size of the subjects or objects represented and placing each of them where they belong on the plane. The depth of the scene is created by combining converging and diverging lines, relative sizes, and areas of varying light and clarity. In this chapter we show you the basic fundamentals of a perspective drawing, the elements that play a part and the types of perspective that can be used, and how to calculate the sizes of the subjects or objects as they move away from the foreground.

The Height of the **Horizon**

The straight line of the horizon is an imaginary line required for any perspective representation because it is the location of the vanishing points, the meeting points of the diagonal lines that define the space and create the illusion of depth. Each model has its own horizon, which helps regulate the space. In seascapes and flat landscapes the perspective horizon coincides with the real horizon, while in landscapes with mountains the horizon is located somewhat below the outline of the mountaintops.

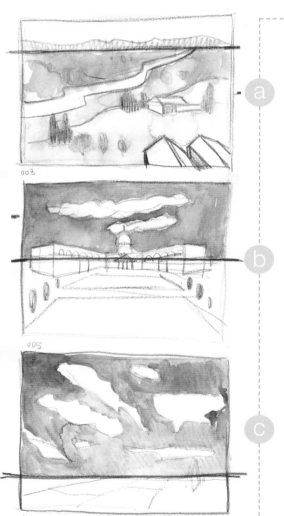

A high horizon allows you to highlight the aspects of the terrain, and the different planes in the landscape become the protagonist of the work (a).

A horizon in the exact middle of the paper is often used in cityscapes and strongly balances the scene (b).

A low horizon barely leaves space for the land and allows the sky to become the subject of the painting (c).

Here the horizon is very low to highlight the mountains, which rise up very high in contrast to the small space where the houses are clustered.

A Fictitious Horizon

Before beginning to draw any object deformed by perspective, you must decide on the height of the view, or the horizon line. This is a simulation of the real horizon, an imaginary line that is located at the height of your eyes. You see it, for example, when you look at the sea; it represents the edge where the sea ends and the sky begins. This line also represents the height and posture of the observer; in other words, it is located at the level of the observer's eyes and moves up or down according to the observer's position. Thus, if the observer is standing, the line is high, but if the observer crouches, the line will move downward.

The Height of the Point of View

This refers to the level where the artist is in respect to the subject of the drawing. It determines the height at which he or she will draw the horizon. There are three possibilities. In a view looking downward, or a high point of view about three quarters of the way up the paper, the space that is created is quite extensive, with the foreground located at the lower part of the paper. This view is very useful for drawing landscapes because it is a greater view of the land. A horizon in the middle of the paper gives you the point of view of a person who feels closer and is part of the scene. Finally, a low point of view results when the person is seated on the ground; the terrain plays a small part, giving all the importance to the sky.

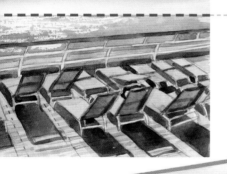

The horizon line helps to control the space. *This high horizon allows you to include many elements in the lower part of the painting and allows the perspective lines of the deck chairs to converge toward it.*

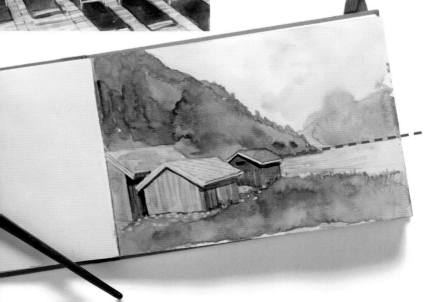

One-Point **Perspective**

Sometimes called parallel or conical, this type of perspective has only one vanishing point, which is located more or less near the center of the horizon line, right in front of the viewer or slightly to one side. It is used when one side of the model is parallel to the picture plane. One example of this is a drawing where train tracks move away into the distance until they meet at a point on the horizon.

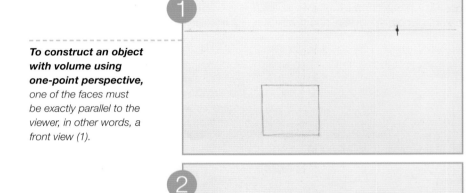

To construct an object with volume using one-point perspective, one of the faces must be exactly parallel to the viewer, in other words, a front view (1).

Mark a point on the horizon line and draw each edge of the cube by drawing diagonal lines that converge on this single point (2).

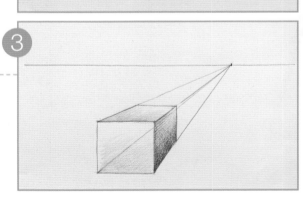

To finish, draw lines that are parallel to the sides of the square to indicate its depth. The result is a volumetric quadrangular form that you can begin to shade (3).

Starting with a Cube

The most simple and graphic way of explaining one-point perspective is by drawing a cube. First draw a square, then, extend diagonal lines from its corners to a single point located on the horizon line. These diagonals suggest the depth of the drawn object, which becomes narrower as it moves away from our point of view. At first you can use a straightedge, but it is best to quickly get used to drawing the cube and diagonal lines by eye and freehand.

One-point perspective is typically used in urban scenes—for example, a view of a street where all the lines of perspective converge on a single centralized point.

Variations with Respect to the Horizon

The image of the cube is not always the same; it can change depending on the height of the horizon line, which will cause the lines to converge at a higher or lower point. If you take a look at the objects that surround you, you will notice that you only see the upper sides of some, while you only see the sides or even the undersides of others. This is because some of them are located below the horizon line, and others are above it. When it is not possible to see either the top or the bottom of an object, it is because it is on the horizon line. If you can see the bottom side, it is because the object is located quite far above you.

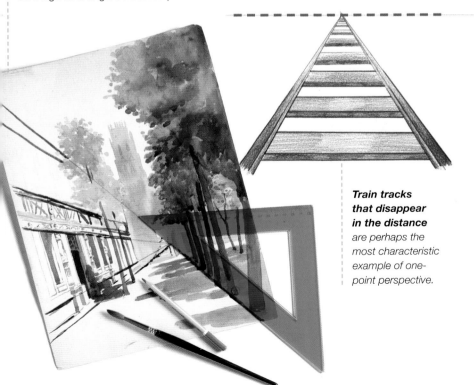

Train tracks that disappear in the distance are perhaps the most characteristic example of one-point perspective.

LET'S EXPERIMENT

A Façade
in Perspective

The perspective effect creates a sense of the door and window moving away from us by slightly deforming their shapes.

PARALLEL PERSPECTIVE
HAS ONLY ONE VANISHING POINT

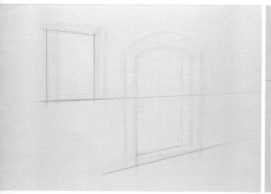

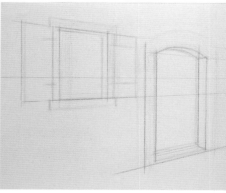

1. Here the vanishing point is located outside the picture plane. To do this you must first place a piece of paper alongside it so you can extend the perspective lines to sketch the shapes of the door and window.

2. Continue to add detail to the initial geometric shapes to adapt them to the appearance of the real model. The lines that define the window frame are used to represent the shutters, while all the perpendicular lines are parallel to each other.

One-point perspective is also known as parallel perspective or conical perspective, and its single vanishing point is located more or less in the center of the horizon line, just in front of the viewer or slightly to one side.

It is used when one side of the model is parallel to the picture plane. One example of this is a drawing of train tracks that move into the distance until they meet at a point on the horizon line.

3. *Focus all of your attention on the door, which is somewhat more complicated than the window because it has a low arch. To draw it use the perspective line as a reference, with the goal of creating a pleasing curve by drawing freehand.*

4. *Make sure that the perpendicular lines of the door are darker, and project new lines of perspective to help you draw the window that has frames and panes of glass—new quadrangular shapes that also must follow the rules of perspective.*

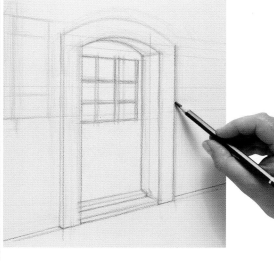

5. *Finish the door, and work on the window and shutters. Pay special attention to the hinges, the braces, and the rest of the details on the shutters. Sketch in the planter with the help of a new perspective line.*

6. *Sketch in the flowers in the planter and finish the windows with their frames and glass panes. The angle of the windows does not follow the perspective that was created up to this point; it is different because the windows are partially open, so they are not on the same plane as the other elements.*

7. *Up until now the lines of perspective have been drawn very lightly, applying little pressure on the pencil. This is because they need to be erased easily so they cannot be seen when the drawing is finished. Their function is only to help create the structure.*

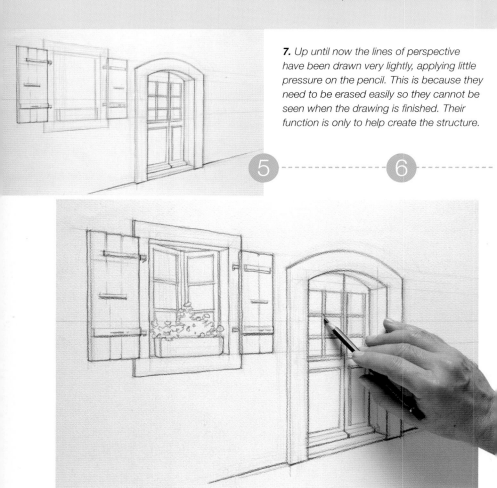

8. *After the architectural elements are clearly drawn and the lines of perspective have been erased, the exercise is finished. This accurate, well-drawn representation can be used as the base for a much more ambitious work of art.*

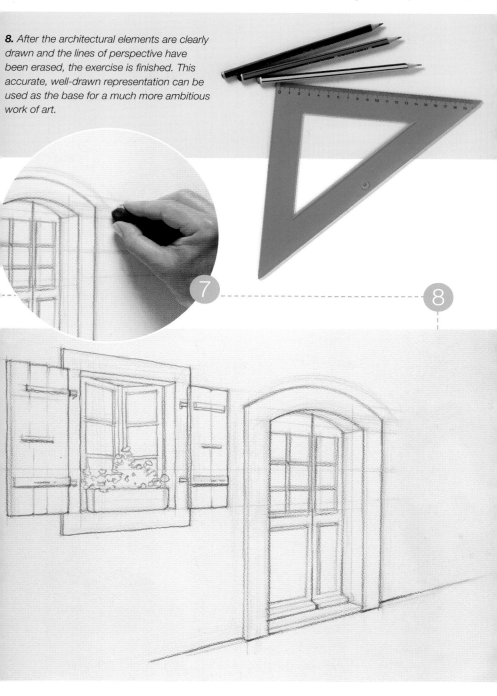

Houses at **Different Heights**

The elements in this scene are placed and drawn using several photographs of houses seen from different points of view as models, using one-point perspective. We will be using the principles of perspective seen in the previous section on a real model, in this case a single family home and a chapel on top of a rocky crag.

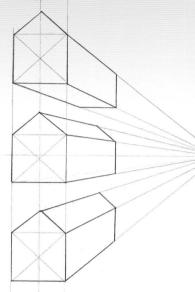

After learning the principles of one-point perspective, you will draw a house in different locations above and below the horizon line to understand how the point of view affects the drawing.

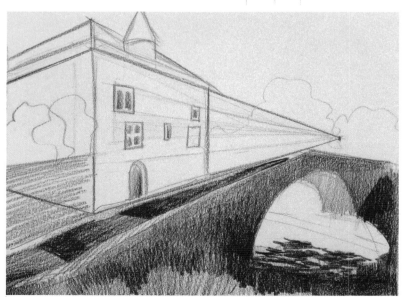

Identifying the height of the horizon and calculating the angles of the lines of the façade will allow you to best block in the buildings so they look more real.

Drawing the Structure

The representation is based on two simple forms: a rectangle and a triangle. The lines that give them depth depend on the vanishing point and the lines of perspective that connect that point with the edges of the geometric shapes. Drawing the lines of perspective will create the walls of the house with perpendicular lines representing the corners. As you can see, as the distance increases the walls look lower, and the wall in the foreground is the largest.

In mountain landscapes it is difficult to fix the horizon. One option is to locate the horizon line lower to make it easier to draw the houses that are at different heights.

Some Considerations

To make use of one-point perspective when constructing buildings, you must keep three basic rules in mind: the object that is represented must have one face that is exactly parallel to the picture plane; the vertical lines must be perpendicular to each other and perpendicular to the horizon line; and you must adapt the foundation of the house to the terrain so that it sits on it in a believable manner and works in conjunction with the flat or sloped area where it is located.

If the architectural element looks more complex, you can pile up boxes or geometric shapes that are projected in perspective. When the model has been completely sketched in pencil, draw over the outlines with darker lines and erase the lines of perspective and the other lines that were used to complete the structure.

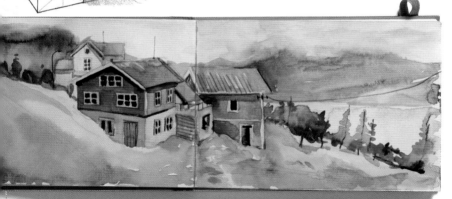

To represent the volumetric forms of some houses constructed on a slope, where it is not possible to clearly see a horizon line to use as a reference, you must have a certain knowledge of perspective.

IN THE STYLE OF...

Christian Skredsvig

(1854–1924)

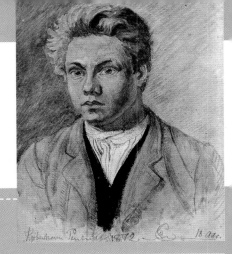

Christian Skredsvig worked in the style of French Realism and the landscape style of the Munch school.

The House of the Poet Vinje in Telemark, *1887.*
Skredsvig often painted landscapes in which solitary figures appear to be walking with a pensive air. This painting from 1887 represents the house of the Norwegian poet Aasmund Olavsson Vinje. It is a small farm at the edge of a forest, below some imposing mountains. The two buildings constitute an interesting exercise in one-point perspective, located on the side of a mountain that creates a strong diagonal composition.

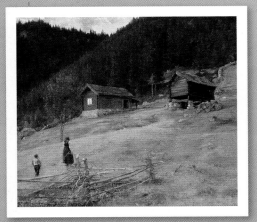

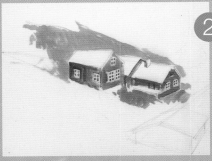

1. *The buildings are sketched using two different perspectives with vanishing points located at both sides of the painting (the one for the nearer house is outside of the paper).*

2. *Use a violet color pencil to indicate the shapes of the windows and correct the straight lines on the rooftops. The first applications of oil paint should be very diluted.*

The son of a miller and raised in a rural environment, Skredsvig demonstrated a great talent for painting at a very young age. His family sent him to Oslo to take drawing classes, and later he visited other important cities, among them Copenhagen, Munich, and Paris, where he became the only Norwegian artist to be awarded a gold medal in the Paris Salon, in 1881. After a period of time in Paris he returned to Norway in 1886 and became one of the most active representative artists of Scandinavian Neo-Romanticism.

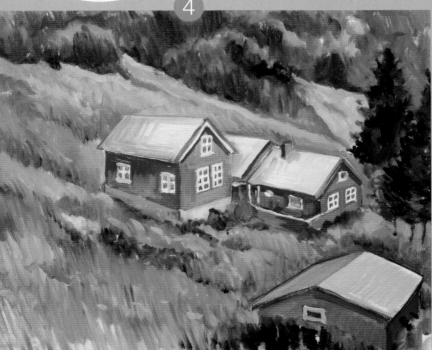

3. *When you have completed the structures of the buildings (without a doubt the most complicated part), paint the landscape with different gradations of green, creating strong contrasts between the well-lit green of the fields and the dark tones of the forest.*

4. *The brushstrokes should be very thick and dense in the upper area of the support and more diluted and linear in the lower part to suggest the texture of the grass.*

Two-Point Perspective

This type of perspective has two vanishing points for the diagonal lines of perspective, which are located at each side of the horizon line. One-point perspective is static and formal, and it does not always relate to the real models. The angles of most objects require that they be drawn in perspective using two vanishing points located at each side of them.

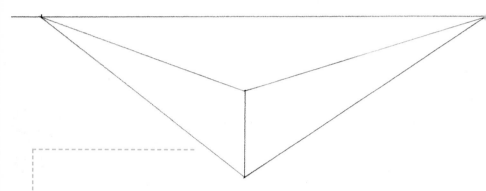

To draw a cube using two-point perspective, use the front edge as a reference. Draw diagonal lines on each side running to the vanishing points that are on each side of the object.

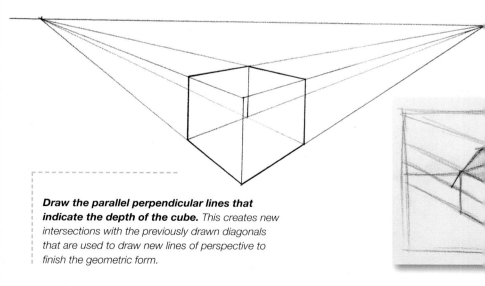

Draw the parallel perpendicular lines that indicate the depth of the cube. This creates new intersections with the previously drawn diagonals that are used to draw new lines of perspective to finish the geometric form.

Two Vanishing Points Instead of One

Oblique perspective, or two-point perspective, is used when none of the faces of an object are parallel to the picture plane, which means that they are positioned obliquely in relation to the viewer. For example, if the object being represented is a building, the nearest part to the viewer would be one of its corners. To construct the two visible faces on each side you need two vanishing points located on the horizon line, at each side of the object that is being drawn. The distance of the two vanishing points from the object is another issue, since the closer they are to the model in perspective, the more distorted it looks. It is a good idea to spread out the two vanishing points, otherwise the resulting images will not be very realistic.

Constructing an Object in Two-Point Perspective

The first step is to draw a horizon line and locate two vanishing points on it that are far enough from each other, considering that the object must be created in the space that exists between the two points. Then project a vertical line that is perpendicular to the horizon line. Draw reference lines from the top and bottom of the vertical line to each vanishing point. These lines of perspective define the depth of each of the sides of the object. The geometric drawing that is created by the lines of perspective will act as the base—as a structure to hold a house, a building, or other object of similar form. Finish by erasing the construction lines.

If the vanishing points are too close together, you will create a distorted view of the object that you are drawing.

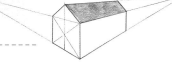

If the vanishing points are located far enough apart, the appearance of the object will be much more natural and realistic.

Two-point perspective is without a doubt the most commonly used technique. It is usually applied in representations of very diverse subjects, from a simple still life of a box to cityscapes or a view of a pier.

THE SUBJECT

Equal Distances in Perspective

When representing a façade with evenly spaced arches from a frontal point of view, the drawing will present few problems. But this same model in perspective will present measurements that change according to the distance from the picture plane, and this can confuse the artist. There is a formula for representing a series of equal repeating spaces, which will help you easily calculate how the distances decrease as they move away.

To calculate how equal distances decrease because of the effects of perspective, mark the divisions that you want to draw on a line that is below and parallel to the horizon line.

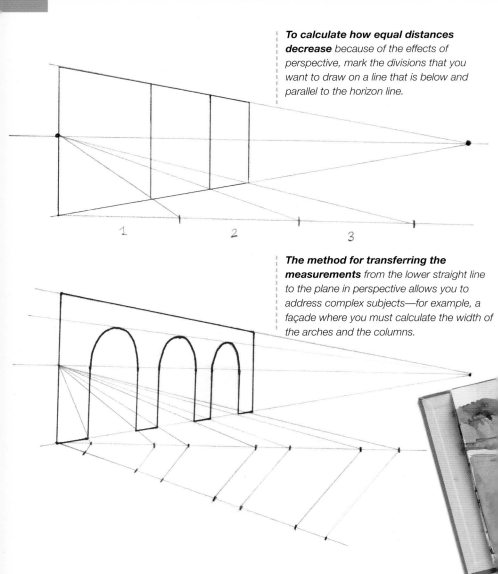

The method for transferring the measurements from the lower straight line to the plane in perspective allows you to address complex subjects—for example, a façade where you must calculate the width of the arches and the columns.

Measuring the Distances

When you block in an object, whether it is an arch or a tree, you must first indicate the horizon line and then the distance between the two nearest elements. The place where the horizon line crosses the vertical line of the first segment is the measuring point from which the subsequent diagonal lines will be projected. Draw a line parallel to the horizon line at the bottom of the plane, and on it mark the number of measures or partitions that you wish to make. Then, draw lines from these marks to the point where the horizon line meets the first perpendicular line. Where these lines cross the lower line of perspective is where the next perpendicular lines should be drawn.

Arches and Columns

In a case where you are making a more complex drawing—for example, representing some arches with columns—you must adapt the previous approach to the new circumstances. Here are four columns and three equal arches. Mark the measurements of all of them on the lower line, making sure they are equal, then immediately project a diagonal line from one of these points to the measuring point. Using a square and a triangle, draw perpendicular parallel lines from the points where the projected lines intersect with the line of perspective. When you have the widths and heights of the three arches, you only need to draw their curved tops.

There is another simpler method that consists of drawing a diagonal from the top of the first post and crossing the center of the second one. Where that line touches the ground determines the position of the next post, and so on.

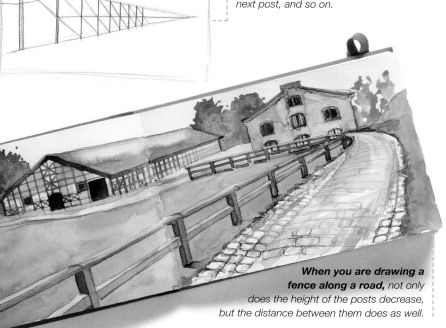

When you are drawing a fence along a road, not only does the height of the posts decrease, but the distance between them does as well.

Representing Interior Spaces

When representing the interior of a room, it is best to define one or two vanishing points at each side of it so that you can construct the limits of the space. When the interior is very deep it is a good idea to use a central vanishing point, but if, on the other hand, the dimensions are more modest, it will be better to define a corner and project the space based on two vanishing points that delimit the floor and the ceiling.

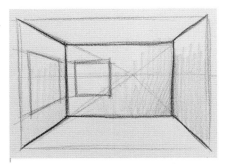

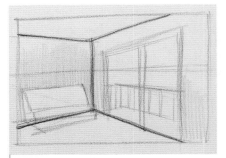

You can choose to use one-point perspective if you want to show three quarters of the room, but this option creates a very symmetrical picture.

It is better to begin at a corner and project the walls from two vanishing points located outside the picture plane. Although the space that is created is smaller, it looks more natural.

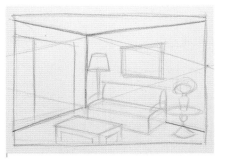

After defining the walls and the lines of the floor and ceiling, the next step is to arrange the furniture, which is laid out in perspective using the same vanishing points. They should be drawn as simple volumetric objects.

Limiting the Interior Space

First you must create the structure or module of the interior space. Draw the horizon line, which can be located right in the center of the paper, and then draw a perpendicular line to represent the corner of the room. From each end of this line draw perspective lines to the vanishing points that extend upward and downward to define the height of the walls (the angles of the floor and the ceiling). Using the same vanishing points, draw other diagonals to locate the doors and windows. All of the straight perpendicular lines should be parallel to the line that defines the corner of the room.

Projecting the Furniture

When indicating pieces of furniture inside a space, you must envision them as simple geometric forms and draw them completely transparent so you can better understand and visualize their internal structure. If it helps, you can draw a rectangle (in perspective) on the floor to use as a reference and better control the position and true dimensions of each object with respect to the space.

Since this representation will show a wide and spacious interior, we have decided to use one-point perspective. The vanishing point is located to the right of the scene so the composition will not be too symmetrical.

Using the previous sketch, begin framing in the furniture and each of the elements that decorate the room. The colors should be based on the light that comes into the room through the windows.

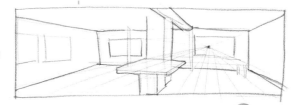

Furniture in Perspective

The best way of representing furniture is by combining different simple forms drawn freehand. The base should be an accurate construction in which each part has an exact size, shape, and place. First draw a geometric version of its shape, which will serve as its structure, and then give it a personal touch, to individualize the most characteristic elements, and add some details. The

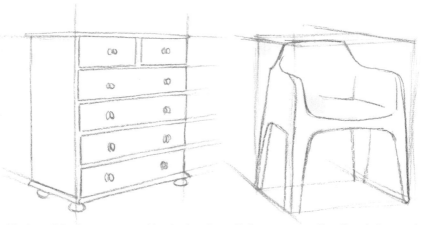

To draw this dresser, *start with a freehand drawing of a large box. Then divide one of the vertical lines into five parts to indicate the height and perspective of the drawers. If you do not use a straightedge, the lines will inevitably appear a bit heavy and unsteady.*

Before representing the chair, *you should create a structure or box seen in perspective, then draw the shape of the piece inside it.*

To construct this sofa, *you must draw a larger structure. It is important to carefully draw the angle of the backrest and to divide each of its parts so that both halves look correct.*

angles of the lines of perspective should not be too pronounced so that the perspective does not look forced.

This piece of furniture was blocked in using one-point perspective, or parallel perspective. Since it was drawn freehand, not all the lines coincide exactly with the vanishing point. What is important is that the drawing looks clean and loose, and much less cold than if it had been drawn using a straightedge.

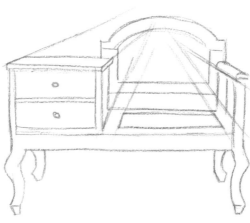

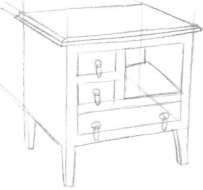

After it is drawn, the piece of furniture can be considered a complete uniform mass, with smooth surfaces that are enclosed by outlines that follow the rules of perspective.

The outlines become more difficult when you must draw an elliptical shape. The solution is to construct a flattened square and locate the ellipse inside it. With a few exceptions, furniture pieces are symmetrical, and they must be drawn very carefully.

Tile **Floors**

When you look at a large floor with regular tiles or wood strips, the farthest ones look smaller and smaller. The lines where they meet, even though they are parallel, look closer together and tighter as they get farther away; in fact, if they are fully extended, they end up meeting at a single distant point. In this chapter we will explain the technical approach for drawing a tile floor with two different types of perspective that an artist can adapt to the circumstances of the model.

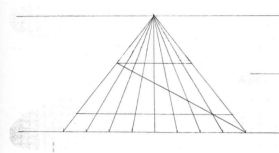

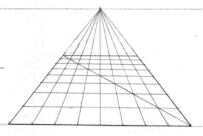

To represent tile with one-point perspective, divide the baseline of the floor into eight tiles of equal size that will converge when the lines of perspective meet at the vanishing point on the horizon line.

A diagonal line that crosses the corners of the tiles will determine the depth of the pieces. Draw lines across these intersections that are parallel to the baseline of the floor.

The grid that is created by a tile floor can be very useful for raising the geometric forms that are used for blocking in the furniture.

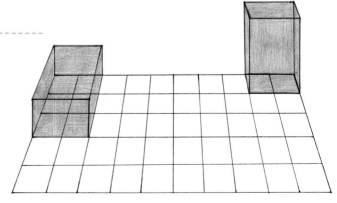

Laying Out a Grid of Tiles

Now we will draw a tile floor, using a technique that requires a single vanishing point. You will be able to use this technique at some point in time. First, draw a box in perspective that will indicate the space where the mosaic will be created. Divide the baseline of the floor into the number of tiles that will be on the floor, and mark the vanishing point on the horizon line. Connect the marks on the baseline to the vanishing point with diagonal lines of perspective.

To calculate how much the tiles decrease with distance, draw a diagonal line that connects opposite corners of the floor. This diagonal line is important, since it indicates the points across which the parallel horizontal lines are drawn that determine the depth of each tile.

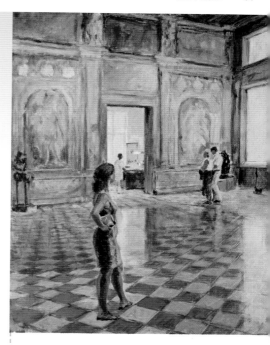

This is a representation of an interior space where two-point perspective was used to render a tile floor.

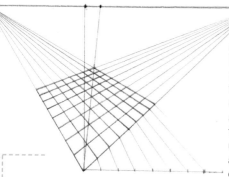

When the viewer is located in a corner of the room, the tile floor should be constructed using two vanishing points to create a view of the floor in perspective.

A Floor with Two-Point Perspective

If the tile floor is to be drawn using two-point perspective, you should first divide the baseline in equal parts (see previous chapters). Then, each one of these marks and measurements should be transported to the floor as it is drawn in perspective using one of the two vanishing points, adding new lines of perspective that converge on the other vanishing point. The intersections created with the previous perspective lines indicate the size and depth of the tiles.

A Hallway with
a Tile Floor

This interior scene is lit from behind, and the floor tiles have a strong perspective.

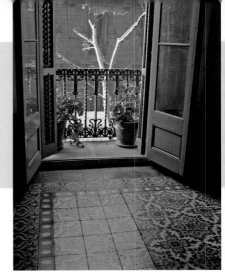

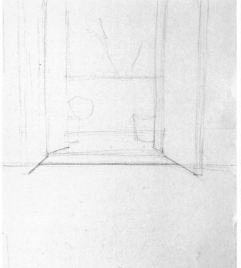

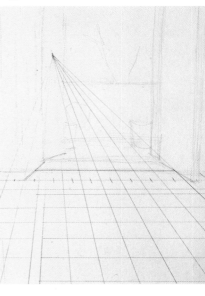

1. To successfully complete this watercolor you will have to spend more time on the drawing phase than on the painting. The sketch should be started with pencil; draw the door, leaving ample space for developing the perspective view of the floor.

2. Do the measuring on one of the horizontal straight lines so that all the tiles are the same width. Draw the lines of perspective from these points to a single vanishing point near the top of the paper.

There are times when using perspective is the only way you can render a complex subject, making a strong, solid drawing and adding form, color, and shading to it to create the final composition. Something like this happens when you wish to draw a view of an interior with a tile floor. One solution is to draw the tiles by eye, but if you are in the habit of taking measurements and drawing lines of perspective, it is better to render the scene using perspective to minimize errors.

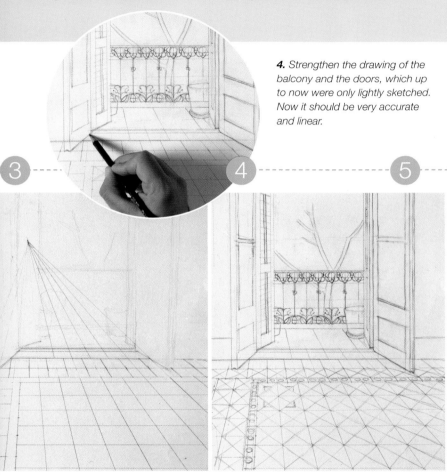

4. Strengthen the drawing of the balcony and the doors, which up to now were only lightly sketched. Now it should be very accurate and linear.

3. At the base of the door the tiles are arranged differently; the seam lines are up with the centers of those that cover most of the floor.

5. Join all the intersections of the tiles with two crossing straight lines. This new geometric grid will make it easier to draw the patterns on each tile.

6. As you work on the sketched tiles, the designs on the floor will also look like they are converging on the vanishing point. The drawing does not have to be too detailed, but it should have a geometric look.

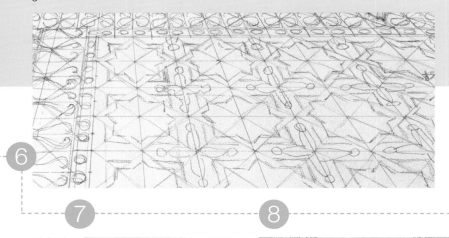

6

7

8

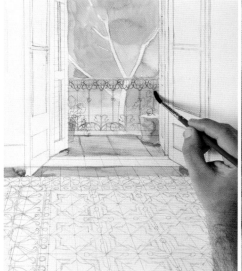

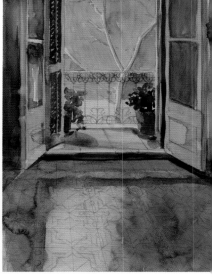

7. When the drawing is finished it should be painted with watercolors. Start with the background, with the space that is seen on the other side of the doors of the balcony, applying very flat, transparent colors.

8. The painting flows quickly, and the first dark washes of watercolor soon cover part of the room and the windows. The doors and the shutters are painted green, while the washes on the floor are very transparent in the lightest area.

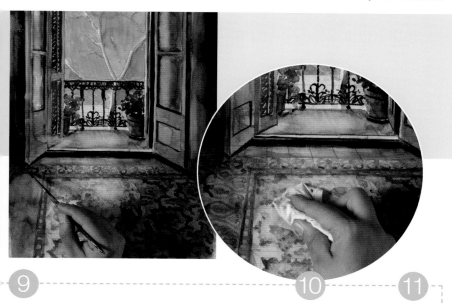

9 ········· **10** ········· **11**

9. With a fine brush and some patience, add the designs on the tiles carefully, following the guidelines drawn in pencil, which are still visible under the washes.

10. Lighten the most illuminated part of the floor while it is still damp by dabbing it with a clean rag.

11. After you add the shadows projected by the flower pots on the balcony, and indicate the reflections of light on the glass in the windows, the watercolor can be considered finished.

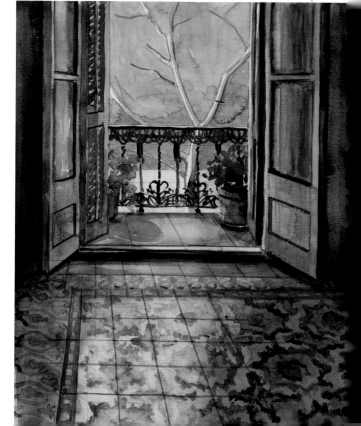

Elevation of a Stairway

Sometimes when you are rendering an interior it will be necessary to represent a staircase, almost always in one-point or two-point perspective. In fact, many artists include slants, slopes, and stairs in their drawings to play with the inclination of planes and to introduce more rhythmic elements that will break up any overly static tendencies caused by the walls. If you are not experienced, drawing a stairway freehand can be complex and confusing, but with the help of linear perspective the work is simplified.

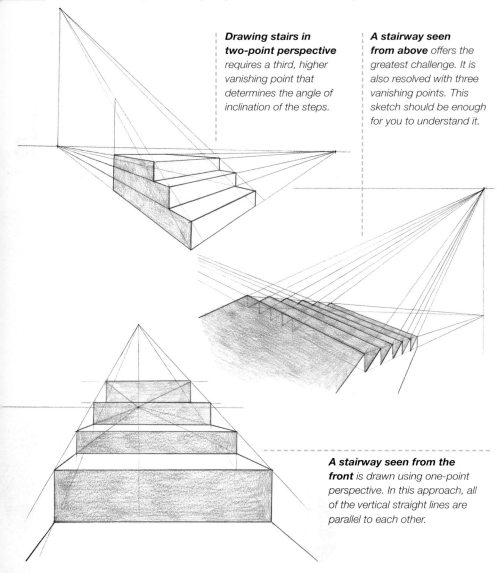

Drawing stairs in two-point perspective requires a third, higher vanishing point that determines the angle of inclination of the steps.

A stairway seen from above offers the greatest challenge. It is also resolved with three vanishing points. This sketch should be enough for you to understand it.

A stairway seen from the front is drawn using one-point perspective. In this approach, all of the vertical straight lines are parallel to each other.

Determining the Placement and Angle

Perspective drawings of stairways, like those of roofs on buildings, are based on the presence of ascending and descending planes. As they ascend, the stairs become narrower and the distance between them is reduced. Before drawing a stairway you must determine its inclination; this can be done with a geometric pencil sketch that simplifies its general form and shows the space that the stairway in question will occupy on the support. After you have taken these measurements, all you have to do is draw the stairway very carefully so you do not make any mistakes. To make it easier to draw and understand, artists will frequently reduce the number of steps.

From Above and Below

When you go up or go down the stairs your point of view will completely change, and so will the angles of the stairs, because you have to add the height of your body to the position of the viewer. When the stairway is seen from the front, from a low point of view, it can be drawn with a single vanishing point located at the upper part of the paper. The height of the steps will be determined by another central vanishing point that will correspond to the height of your eyes. If you are standing at the top of a stairway, the drawing will be more complicated since it will need three vanishing points to determine the angle of the stairs, the way they move away, and the way they progressively grow smaller in size.

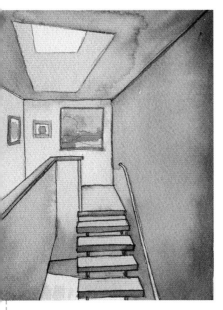

Front view of a descending stairway, drawn with one-point perspective, where the vanishing point is located at the bottom of the window in the background.

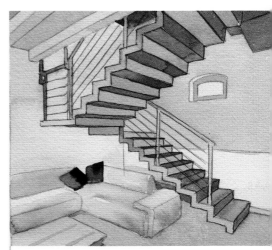

After learning the system you can draw all kinds of stairways, resolving different situations in reference to the angles of the stairs as well as to variations in the height of the horizon line.

Projecting **Shadows**

The light that illuminates an interior from one side of a room, such as from a window or a lamp, will project long shadows around it that, in a certain way, are also subject to the laws of perspective. Their shape and size are determined by the intersection of the rays of light with the vanishing points, but their distinct form depends on the angle of the floor and the relief of the surface that they are projected on.

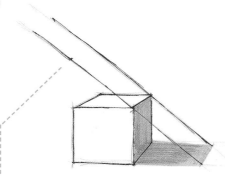

In one-point perspective, the shadow looks more deformed as a result of the intersection of the light rays with the lines of perspective.

The shadows cast by an object drawn in two-point perspective illuminated from a source at one side are rendered with lines of perspective that are parallel to each other.

The intense light of the sun penetrates this room through the small window, casting the shadows of the objects on the floor.

Shadows with One-Point and Two-Point Perspective

Shadows projected from a light source to the side and above that are cast on an object represented in perspective are seemingly parallel. Their length depends on the angle of the lines of perspective. On the other hand, the lines that define a shadow of a vertical figure in two-point perspective are never parallel, but spread to form diagonal sides with different angles. By connecting the light source with each of the corners or most outstanding parts of the solid object, you will find the exact length and form that describe the shadow on the plane.

The Vanishing Point of a Shadow

When a scene is illuminated by a single light source, the vanishing point of the shadows is located at that source. The shadows will be well defined if they are near the light and more blurred if they are farther away. Shadows projected on an upward slope are shorter, and they will be longer if they are projected on a downward slope. To calculate the length of a shadow on one of these slopes, draw the lines of perspective that proceed from the light source to the corners of the chimney and extend them until they reach the sloping horizontal plane; then, all you have to do is draw the silhouette of the shadow.

When a body projects a shadow on an upward slope, it is shortened.

Contrarily, when it casts a shadow on a descending slope, the shadow will be longer than normal.

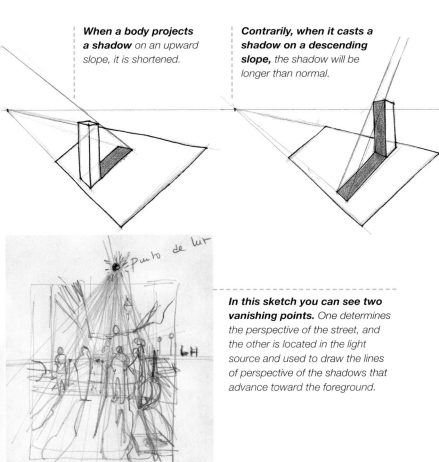

In this sketch you can see two vanishing points. One determines the perspective of the street, and the other is located in the light source and used to draw the lines of perspective of the shadows that advance toward the foreground.

Vincent van Gogh
(1853–1890)

Although van Gogh knew the rules of perspective perfectly well, in his work he adapted them to his own needs and came up with excellent results.

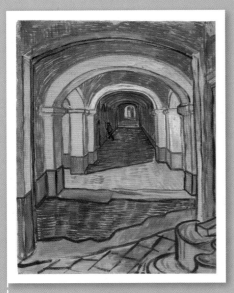

Corridor in the Asylum, *1889.*
From mid-June until the end of August 1889, a relapse of his illness left van Gogh terribly weakened and reduced his mobility, which caused him to be exhausted much of the time and unable to go outside. This is when he began to copy works of the great masters from photographs and paint interior scenes. This corridor in an asylum is a very important example; it uses a visual perspective that has a single vanishing point located on the door in the background.

1. Draw the columns by eye, focusing on the diminishing size of the pillars and the doors. Then paint over the drawing with violet oil paint diluted with turpentine.

2. Cover all the spaces with a mixture of orange, cadmium yellow, and a little white. The resulting color should be diluted with turpentine. The goal is to cover the white of the support to have a more interesting background color to work on.

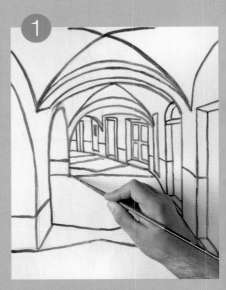

CONSTRUCTING TORTUOUS SPACES

Van Gogh is thought to be one of the greatest masters of all time and a precursor of the 20th century, especially of the Expressionists and the Fauvists. His work is not exactly known for his careful use of perspective, although we must appreciate the way he adapted it to re-create some tortuous spaces, constructed with imprecise and expressive forms. This is especially evident where he incorporates strong diagonal perspectives that help compose wheat fields, the courses of rivers, bridges, and even interior scenes, like his famous room in Arles.

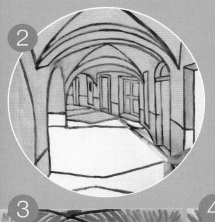

3. The previously applied diluted paint will dry very quickly, and it will allow you to add some first brushstrokes of colors without worrying about them mixing with those underneath: white on the walls, turquoise on the pillars and where the arches begin, and raw sienna mixed with a touch of orange on the ceiling.

4. Apply each color with short brushstrokes that follow the direction of the surface they define, just as van Gogh did. The lines that define the architecture are not covered and should always be left visible.

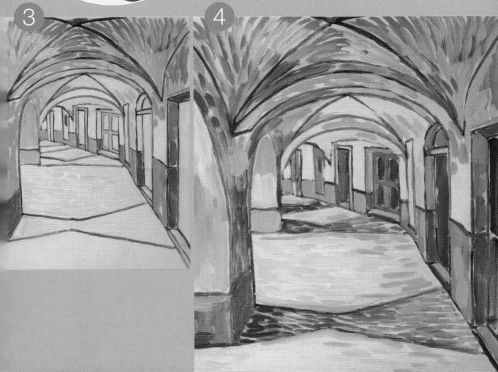

The **Urban** Scene

In the first part of this book we have mainly talked about the bases of linear perspective and explained how to construct the regular forms based on diagonal lines that converge toward one or two vanishing points located on the horizon line. However, reality, and especially the urban landscape, presents us with forms that are much more complex and have unavoidable complications. In the following section, we will take a look at the architectural scenery that makes up the city—the public spaces—offering solutions to problems and approaches that can be very useful for the artist. It is a matter of understanding perspective projections in the cityscape and coordinating the construction of the spaces in a well-proportioned and coherent manner.

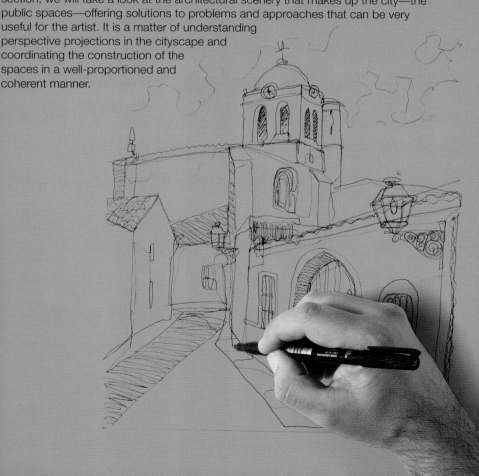

Difficulties in **Representing the City**

The urban landscape is a compendium of different perspectives, each one of them with numerous challenges that arise when you attempt to make an accurate rendering of the buildings and the urban furniture of which it is composed. You begin with a horizon line and the vanishing points that allow you to project the main façades. The structure of the buildings will be the result of combining and superimposing different geometric shapes and volumes as if they were construction toys.

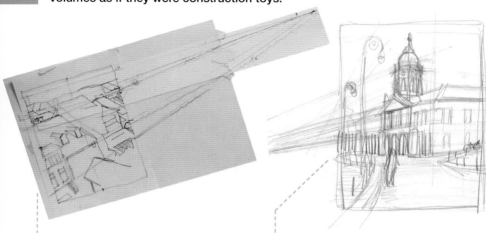

Often, the vanishing points will be outside of the margin of the paper. *This can be remedied by extending the working area with a piece of paper in the right place.*

In urban scenes *it is more often necessary to plan the drawing in perspective so that the architecture can be sketched accurately and with correct proportions.*

A planned suburb *will also benefit from an intuitive freehand perspective, which is not precise but very effective, especially if you are trying to create a dynamic and attractive interpretation of the subject.*

Outside the Picture Plane

Before starting to draw a cityscape, you must locate the vanishing points. Take two or three long rulers and place them on the photograph (if you are using a photograph as the model) or directly on the white surface of the support, so you can lay out the space and determine if the vanishing points are going to end up outside the paper. Locate the vanishing points very far apart, outside of the picture plane, so that the scene being represented will look realistic, natural, and without any exaggerated deformities. This is done by enlarging the surface of the drawing, that is, attaching two pieces of paper at each side of it so you can see the vanishing points and comfortably draw the perspective lines. After the scene has been completed, you can remove the additional paper.

The Urban Grid

There is a way of organizing the urban space, rescuing it from the apparent chaos and disorder that usually engulfs it, especially when the point of view is elevated. Some artists plan the work on a grid made by drawing lines of perspective from two vanishing points that are very far apart. It looks like a tile floor that creates a screen on which you can begin placing each building. This means slightly displacing their true positions so that they coincide with the grid and render their diminishing sizes in a more harmonious and progressive manner. Thus, using the guidelines created by the grid on the ground, the buildings can be raised in an orderly way as if they were geometric figures.

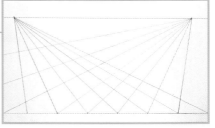

One way of planning a vast extension of buildings is to use a perspective grid as a guideline.

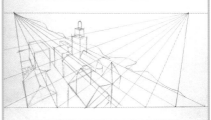

The buildings are raised from the grid on the ground, making sure that each coincides with a quadrant. The picture will then look much more harmonious and orderly.

An Urban Scene with **Two-Point Perspective**

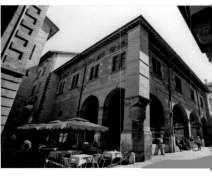

This is a classic example of two-point perspective—a view of a building from one of its corners, with two façades in perspective.

1. *Before starting the drawing, make a small sketch on a separate piece of paper to help verify that both vanishing points are outside the picture plane.*

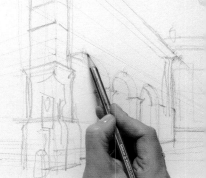

2. *Using the two vanishing points at each side of the picture, draw the box—that is, the building seen as a simple volumetric form, with its corner in the center and the two façades in perspective.*

3. *Draw new lines of perspective on the façade to help set the heights of the arches and the windows. With the spaces framed in, draw them freehand, keeping in mind that the sizes progressively become smaller.*

This historic building is a good example for understanding how to project a building using two-point perspective and guide the viewer's eye across both its façades by properly reducing their proportions with the help of the lines of perspective.

You must synthesize the box-like building into a large volume on which—little by little—you will add some details, the openings and the architectural ornaments, to define it in the context of the streets where it is located.

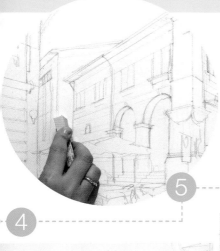

5. When you feel that the drawing has sufficient information, very carefully erase all the lines of perspective that were used as guidelines so they will not be seen through the watercolor.

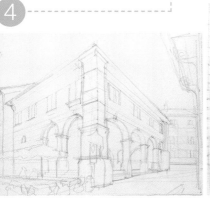

4. Draw some new lines of perspective from the vanishing point on the left, and then do the same on the other façade. This will aid in drawing the openings and the correct angles of the windows on the uppermost floor.

6. Now start the coloring phase. Begin with the background, painting the ground with cobalt blue and a touch of carmine, and the façade facing the street in the background with burnt sienna.

7. *While the paint is damp, you can make small incisions or sgraffito marks with the handle of the brush, leaving some lines that will break up the uniformity of the color.*

8. *The illuminated façade can be covered with a very transparent ochre wash. This color corresponds to the area that receives the greatest amount of light. The windows in the background should be painted with a violet wash.*

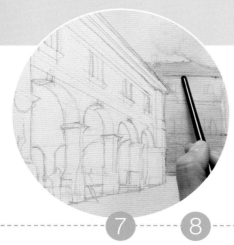

9. *Use browns to paint the eaves under the roofs and a violet wash to project their shadows on the façade at the left. Use the handle of your brush to make a zigzag sgraffito under the eave. The façade on the left is finished with strong contrasting shadows, especially beneath the arches.*

7 8 9

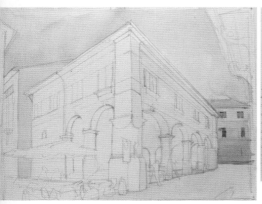

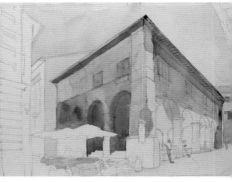

THE SUCCESS OF THE EXERCISE CONSISTS IN KNOWING HOW TO SYNTHESIZE THE BOX-LIKE BUILDING

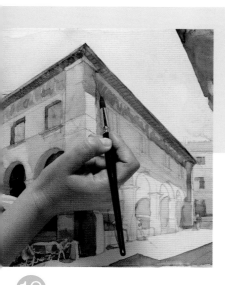

10. *The work should be continued with patience, the strokes of color becoming more precise, but they should not present any problems if you pay attention to the guidelines of the initial pencil drawing. It is not necessary to be too precise; it will be enough to suggest the details.*

11. *The long process culminates with the representation of the people and the terrace of the cafe at the bottom of the street. Use a black conté crayon to add the final details: the streetlight on the left, some lines on the windows, and the spirals that form the cornices on the upper right of the painting.*

10 — — — — — — — — — — — — — — — 11 — — — — — —

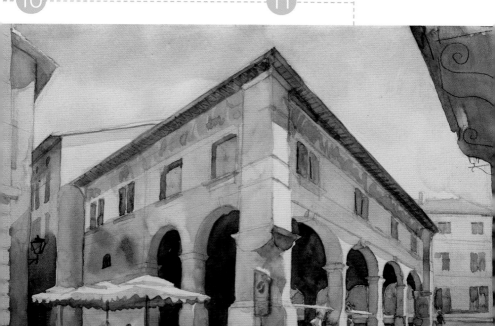

Perspective with **Three Vanishing Points**

Perspective drawings that use three vanishing points are reserved for very special cases: when the object that is being represented is very tall, or when the viewer is located very high above the object, as if he or she were flying over it in a small airplane. The image that best shows this kind of perspective is a view of a skyscraper moving away from you that shows the floors becoming smaller as the building gets higher.

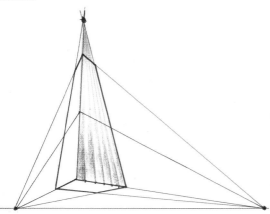

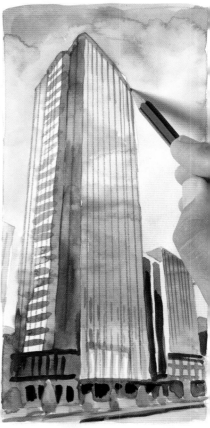

In this representation of a **skyscraper** *from a point of view that is very high above it, you can see how the three vanishing points work.*

When you draw a very tall building seen from its base, *the third vanishing point is located very high above it. This causes the structure to narrow as it gets higher.*

Incorporating a Third Vanishing Point

This is also known as aerial perspective. It is applied by using two-point perspective with the two vanishing points that are on the horizon line on each side of the subject, along with a third point that can be located very far above or below the horizon line, depending on whether the object is seen from a high point from the base. This means that you will not be drawing any parallel vertical lines, since the lines that would appear to be vertical to the horizon line now converge toward a third point to create the illusion of height.

An Expressive Approach

Three-point perspective is forced and not very common, so it is not usually used in representations of urban landscapes. However, fans of architectural drawing should consider it as an approach, since it adds a sense of height that is very useful in some pictures, especially when the viewer is located at the base of a very high building. The third vanishing point can be moved toward the model for the purpose of making the perspective more pronounced, making the lines of perspective even more angled and making the representation look unstable, aggressive, and even dramatic. Therefore, it is generally used to create intimidating, spectacular, and menacing effects.

__Aerial perspective__ is more common than you might think; in fact, it is present in many of the photographs you take.

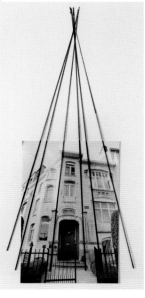

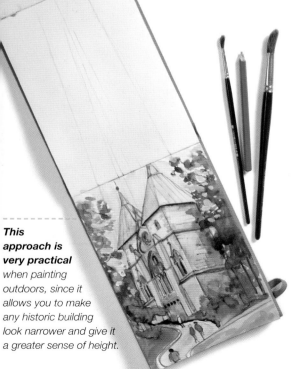

__This approach is very practical__ when painting outdoors, since it allows you to make any historic building look narrower and give it a greater sense of height.

A Building with
Aerial Perspective

If you look at the bell tower of a church from a point of view very near its base, you will see that the building gets smaller as it moves toward the sky.

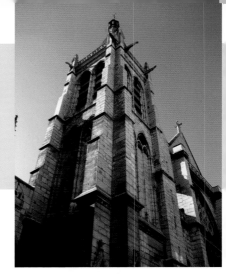

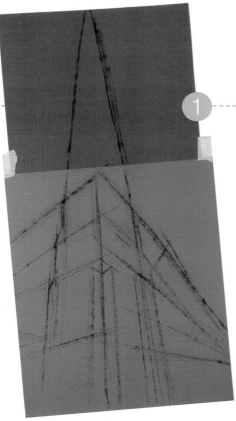

1

2

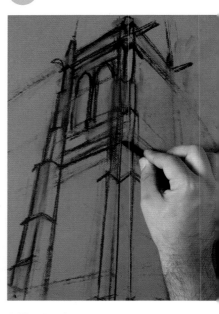

1. Lay out the building using two horizontal vanishing points and a third one that you must locate above the top edge of the paper.

2. The sketch creates an exaggerated perspective that creates the sensation of a high building. Draw the architectural elements with charcoal over the sketched lines of perspective.

If you remember what was explained in the previous section, it should be easy to draw any scene with aerial perspective. In this exercise we will be drawing a tower seen from the base of a historic building, as you will see in the model in the following step-by-step exercise, attempting to give it a correct angle to accentuate the sense of diminishing size and height as it moves upward, even going as far as distorting it to increase its vertical projection even more. The goal is to impress the viewer with a very sharp pyramidal composition, using pastels as the medium.

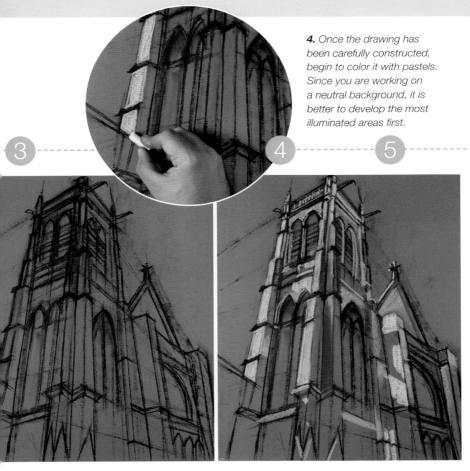

4. Once the drawing has been carefully constructed, begin to color it with pastels. Since you are working on a neutral background, it is better to develop the most illuminated areas first.

3. The façades will be finished in a few minutes. The cornice and the base of the windows angle toward the lateral vanishing points, while the height of the windows and the pilasters converge toward the sky.

5. Indicate the highlights with very light gray and blue colors, the main areas that receive the intense sunlight. Then shade these areas with sepia or salmon rose.

6. Begin darkening the most intense shadows with a mixture of greenish sepia and burnt umber. The intermediate shadows are barely touched because they are the same tone as the gray of the paper.

7. Add shades of salmon and blue-gray in the illuminated areas, and blue and violet on the walls of the bell tower. Reinforce some of the black lines with a stick of black chalk.

8. All that is left is to paint the sky with a combination of three blues: a very light blue on the lower part of the picture, and the other two more intense and saturated blues in the upper areas. All the colors should be blended with your hand.

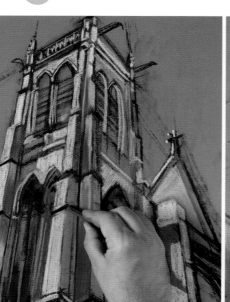

A BUILDING DRAWN WITH AERIAL
PERSPECTIVE DISAPPEARS INTO THE SKY

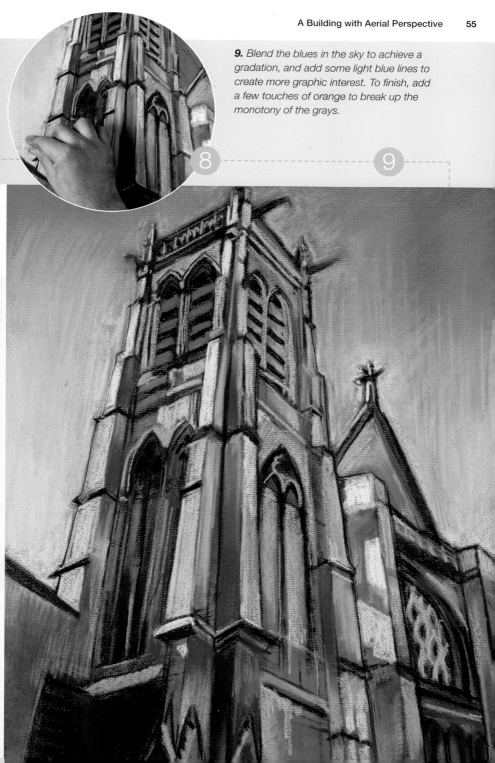

9. Blend the blues in the sky to achieve a gradation, and add some light blue lines to create more graphic interest. To finish, add a few touches of orange to break up the monotony of the grays.

8

9

Canaletto
(1697–1768)

This Venetian artist, whose real name was
Giovanni Antonio Canal, was responsible for
making an iconic image of his native city of
Venice, which he painted a multitude of times.

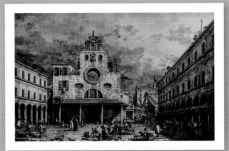

1. Since it would be very complicated to
apply Canaletto's methods, this exercise will
limit itself to reproducing a historic building
with washes, just like he did. The first step is
to lay out the perspective.

**View of the Campo di San Giacomo di
Rialto,** circa 1758.
Canaletto's technique is based on the
application of a modified perspective that
he then complemented with a very careful
study of the light. Canaletto did not represent
this plaza in a photographic or topographic
manner; if you compare this drawing to the
actual scene, you will see that he notably
modified the model to achieve his desired
effects. He composed the urban space
based on an assembly of different sketches,
combining different points of view, and
changing the angles and outlines of some of
the façades. However, the results are so real
that many of his contemporaries believed
that the artist only painted what he saw
before him.

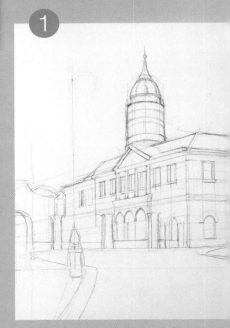

A VAST KNOWLEDGE OF
THE RULES OF PERSPECTIVE

Canaletto became famous for his urban scenes of the city where he grew up, Venice. He was born into a family of painters specializing in theater scenery, developing his vast knowledge of the rules of perspective, which was necessary for creating imaginary spaces for the backdrops of operas. During his stay in Rome in 1719, Canaletto became interested in urban landscapes. He treated the city as if it were a stage where the scenery could be changed, modifying some perspectives and altering the placement of the buildings to achieve an image that was more idealized than real.

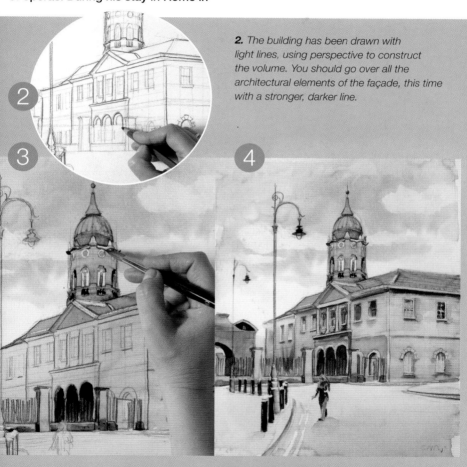

2. The building has been drawn with light lines, using perspective to construct the volume. You should go over all the architectural elements of the façade, this time with a stronger, darker line.

3. Render the shadows with just three shades of Payne's gray watercolor. First paint the sky and cover the asphalt and the façade with a very light gray, then you can attend to the details.

4. The most detailed work is concentrated on the tower; the openings in the building's façades are more loosely sketched. The linear elements, like the streetlights and the screens in the background, can be finished with a black pencil.

Acetate as an Aid

Vinyl acetate and cellulose acetate are sheets of tough, transparent plastic invented in the middle of the 19th century. Graphic artists and fine artists employ them because they can be used to overlay images, especially in technical drawings and animation. They can even be used for identifying and correcting problems with perspective, and for laying out lines as a test, before deciding how to approach a subject.

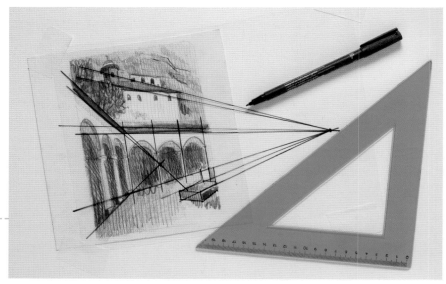

Acetate is a sheet of transparent plastic that allows you to overlay lines of perspective on any drawing to check its accuracy.

Many artists use it for studying the perspective of photographic models before starting to paint them.

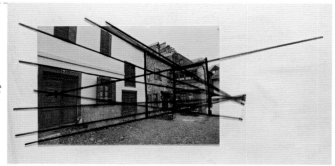

Planning with Acetate

It can be helpful to consider using acetate as a visual aid for analyzing the perspective in a photographic model. The process is simple. You lay a sheet of acetate over the photograph and attach it with adhesive tape. The size of the acetate should be much greater than that of the photograph. Use a ruler to extend the lines of perspective until you find the vanishing points, many of which will be outside of the photograph itself. This analysis will provide valuable information for planning the artistic project, which will help you decide whether the image that you hope to create is worth the effort, because of its complexity, or if it requires some modification to adjust it to your vision or style.

A System for Correcting Errors

Acetate can be a great aid in studying drawings and paintings done freehand, relying on our intuition to check if the illusionary space adapts to an accurately developed perspective. You just have to place it over the drawing, watercolor, or painting, and using a permanent marker and a ruler, trace the horizon and the vanishing points. It is a simple, useful method since it allows you to correct inaccuracies in perspective applied to the drawing and repair the errors we habitually make.

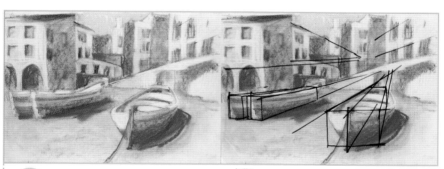

At first glance, it might seem like this on-site sketch has correctly resolved the perspective (a).
The acetate is a "stool pigeon" that will help you identify the errors and see how the lines of perspective in this drawing "are a little disoriented" (b).

Drawing on acetate requires using special markers with an alcohol base, which allows it to be reused many times after being washed off.

A Few **Errors** in Perspective

Perspective is a complicated technique; it requires you to pay attention to the measurements, the projection of structural lines, and many other details that often confuse the artist. Having to assimilate and pay attention to everything causes some doubts, and sometimes errors

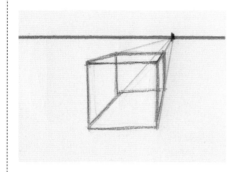

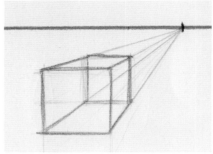

When you draw a cube or quadrangular structure in perspective, you must remember two basic guidelines: do not have the vanishing point too close, and do not allow any of the lines to cover each other.

The best way to work is to stay far away from the vanishing point and to represent the object as if it were transparent, like glass, which will allow you to even see the sides that would otherwise be hidden.

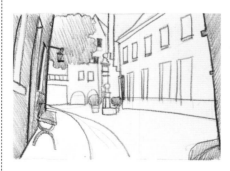

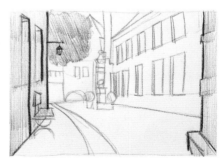

When drawing urban scenes based on photographs, the façades of the nearer buildings will seem slanted, and many artists reproduce them just as they see them.

The twisted façades can cause an error in perception, so it is better to correct them with straight perpendicular lines, which will give the entire scene greater stability and order.

are made that will not be detected until after the painting has been finished and it is too late to correct them. To avoid, or at least minimize, the chances of this happening, we show some of the most frequent errors that you should watch out for.

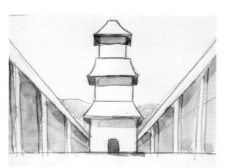

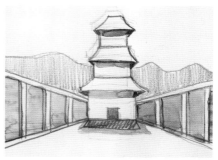

There are vanishing points that are not very common at all, but that many artists use; these are points located at ground level. They are not natural and do not correspond to a point of view usually seen by humans.

You must elevate the horizon line so the viewer will not feel like he or she is laying on the ground, to present a point of view that is more natural and not forced.

When drawing a still life, some artists treat each object in a way that is too individualized, and the ellipses of cylindrical objects will look different because each will follow a different guideline.

It is better to begin with a sketch that gives the ellipses the correct angle of inclination and determines their heights so that all the objects are governed by the same criteria.

Painting **Rooftops**

This model is a good example of how a simple agglomeration of rooftops can become an attractive subject and a big challenge.

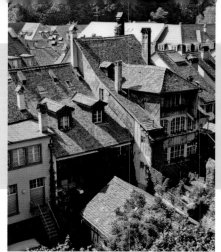

PERSPECTIVE AND SUPERIMPOSED PLANES

1

2

1. The lines of perspective for this scene are located outside of the drawing, so it is necessary to add a paper to locate the vanishing point (see previous examples).

2. Cover the entire background with diluted burnt sienna to counteract the white of the support. Be careful not to erase the lines of perspective drawn with charcoal.

The city offers many good opportunities for the lover of perspective. The search for agglomeration, superimposed planes, and the picturesque cause many artists to become interested in views of rooftops, which offer a succession of rhythmic forms that create a landscape composed of bricks and roof tiles. The arrangements, angles, and forms of the rooftops are complex, so it is necessary to make a preliminary drawing to sketch a certain number of perspective lines that, in addition to acting as a layout, allow you to make a more or less coherent and balanced representation.

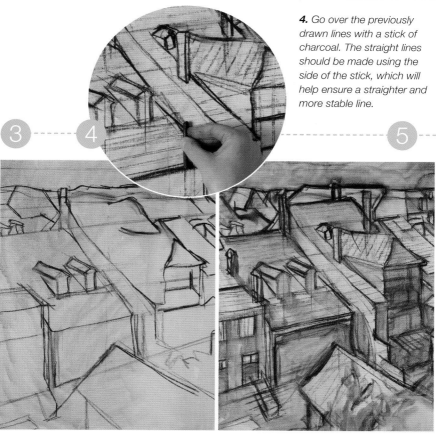

4. Go over the previously drawn lines with a stick of charcoal. The straight lines should be made using the side of the stick, which will help ensure a straighter and more stable line.

3. Begin blocking in the façades and inclined planes of the rooftops over the lines of perspective. All the lines are drawn freehand, without the aid of a ruler.

5. Before painting, lightly wipe the drawing with a rag so that the charcoal dust will not come off and muddy the colors of the paint. The lines will be faint, but still very visible.

6. *The painting is done using very thick, undiluted oils. Start with the vegetation at the top, which outlines the silhouette of the rooftops, and then address some of the light areas on the façade.*

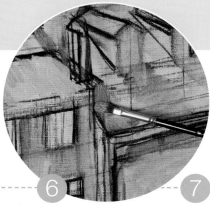

8. *The point of view, the placement of the brushstrokes on the painting, and the way that the forms can seem abstract and topographic at the same time make this ambitious work very dynamic.*

9. *The straight lines of the railings and window frames can be resolved with the edge of a spatula and some paint. Take it from the palette and press lightly with the straight side of the tool.*

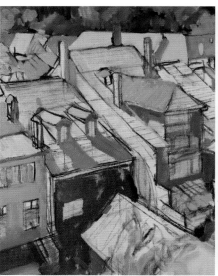

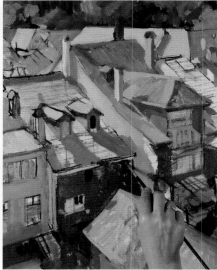

7. *At the same time you are painting the light areas you can add the darkest ones, which correspond to the façades and the projected shadows. The dark tones are necessary for appreciating the outlines and emphasizing the most illuminated areas.*

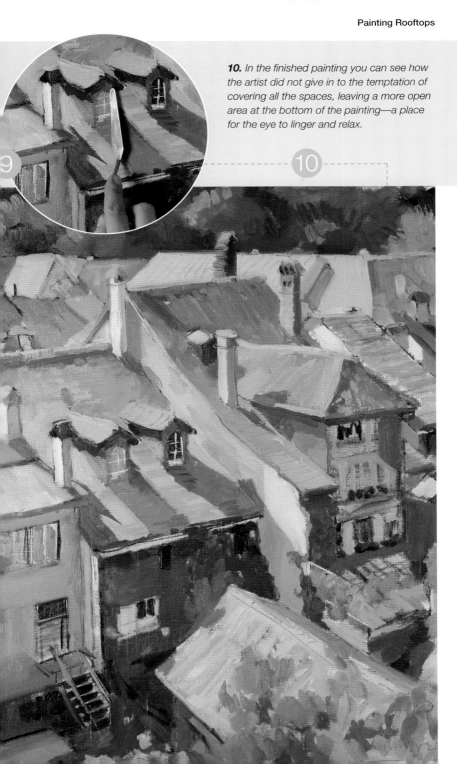

10. In the finished painting you can see how the artist did not give in to the temptation of covering all the spaces, leaving a more open area at the bottom of the painting—a place for the eye to linger and relax.

THE SUBJECT

Constructing an Ellipse

To draw a circle in perspective, you must rely on a square and inscribe a circular form inside it. The square will always touch the circle exactly in the center of its four sides. When you collapse the square by projecting it in perspective, you will end up with an elliptical shape that is the circle in perspective. The ellipse can have many different shapes, from a nearly circular figure to a straight line, including all the intermediate phases. Let's look at the different possibilities offered by this approach to drawing.

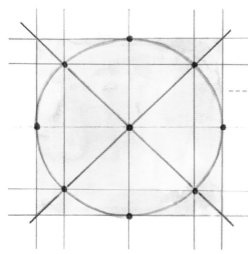

The eight-point method *relates the circle to the square in which it is drawn. There are four tangent points and another four where the diagonals of the square intersect the circle.*

Construct the square in perspective. *Draw the lines of perspective and then draw the ellipse, making sure that the form coincides with the eight key points.*

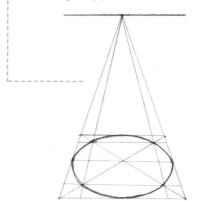

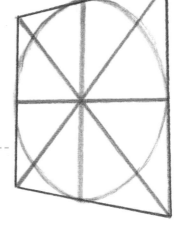

From there, a square is simple to draw in perspective, *no matter its orientation, and it is easy to locate the eight points needed to draw an ellipse on it.*

An Ellipse in Perspective

If you draw a square in perspective, creating the impression that one of its sides is narrower, farther, and moving toward a vanishing point, it can be used to create a perspective view of a circle by inscribing the circle inside it. To better understand this process, we will select eight key points in its circumference and put them in perspective to more surely trace the elliptical deformation. When drawing ellipses, you must keep in mind that neither ellipses nor circles ever have points. No matter how narrow the end of an ellipse, it is always a curve. It never is broken or has corners. The curve can never be too full since the ellipse is a regular curved form, not a teardrop with one side wider than the other. Therefore, watch out for poorly drawn ellipses.

An Ellipse in Relation to Point of View

The shape of an ellipse is determined not only by the effects of perspective but also by the artist's point of view. If you draw seven circles of the same size in one-point perspective located at different height, your perception of each one will be very different. The central circle is located at eye level, the same height as that of the viewer, so only a very narrow elliptical shape will be visible, almost a simple line. The ones located below this point will show their upper side, while those located above will only show the bottom side. This also means that the farther the circle is from the viewer's eye level, the rounder the ellipse.

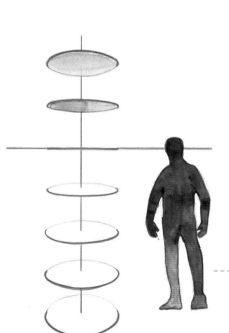

The curves of an ellipse are smooth, rounded, and never end in a point, nor are they tear-shaped; both sides must be symmetrical.

At eye level an ellipse will be perceived as a simple line, then the elliptical shape will change depending on where it is located below or above the line of sight.

Cylindrical Forms in Perspective

When drawing cylinders, it is best to always use a box made with a rectangular prism that will act as a sort of structure and make it easier to develop the cylinder in perspective. The use of a box as a preliminary drawing allows you to draw the cylinder from any angle with few difficulties. After you have mastered the drawing of cylinders, you can develop the form and achieve good results for drawing any object that has a curved or cylindrical shape.

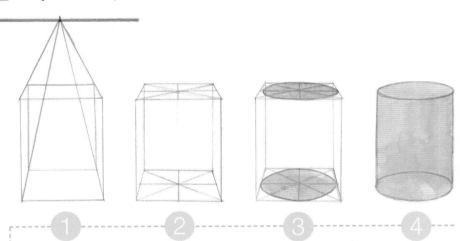

1. To construct a cylinder in perspective, first project a rectangular prism shape in one-point perspective.

2. Connect the corners of the upper and lower squares to find the center of the circle.

3. Draw the ellipses using the method of the eight points.

4. Draw two straight lines to join the sides of the ellipses, and you will have a created a cylinder.

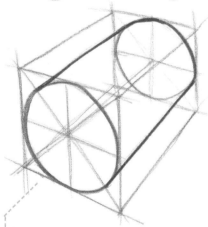

After you have mastered the method of drawing a cylinder in perspective, you should have no problem drawing it from any position.

Drawing a Cylinder in Perspective

First draw a rectangular box in one-point perspective, with four rectangular sides and two square sides, the top and bottom. Inside each square shape, now deformed by the perspective, draw two circles. Next, join the two circles with parallel lines to form the cylinder. Go over the outline of the cylinder with a heavier line and remove the structure of the box with an eraser. After you understand this process, you can represent a cylinder from any point of view by just changing the perspective of the box that serves as the structure.

A Public Fountain

Developing a cylinder in perspective can be very useful for drawing other prismatic shapes seen in urban elements like kiosks, streetlights, fountains, etc. First draw a vertical axis and then project four ellipses that can be turned into cylinders. To convert the cylinders into an octagonal box, draw an octagon above the ellipses and project parallel vertical lines from each of the corners to the lower ellipses. These points of intersection of the two ellipses create the corners of the octagonal prism that create the base of the fountain. Erase the upper figure and finish drawing the fountain with a firmer line.

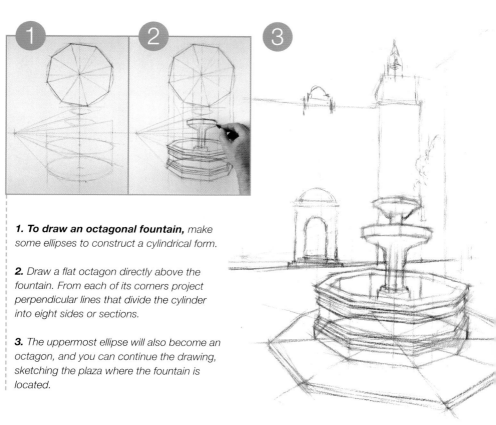

1. To draw an octagonal fountain, *make some ellipses to construct a cylindrical form.*

2. *Draw a flat octagon directly above the fountain. From each of its corners project perpendicular lines that divide the cylinder into eight sides or sections.*

3. *The uppermost ellipse will also become an octagon, and you can continue the drawing, sketching the plaza where the fountain is located.*

An Urban Scene **with Projected Shadows**

This model consists of several strongly backlit pedestrians; for practical effects you can remove a figure or two to balance the drawing.

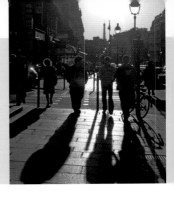

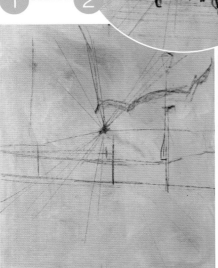

2. *Project the lines of perspective in a radial array to construct the façades of the buildings on the left and the angle of the street. These same lines can be used to determine the heights of the people.*

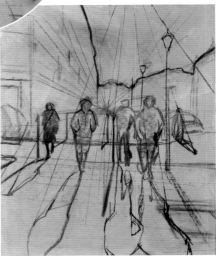

1. *Cover the background with diluted blue, then make a preliminary drawing. First, focus on the area of the street, which should be constructed using a single vanishing point located in the center of the painting.*

3. *The sun, which is the only source of light here, is quite high and radiates new lines that can be used as a reference for calculating the perspective of the shadows projected by the figures.*

In the previous chapter we explained that shadows are governed by their own "perspective" that is constructed with a few imaginary lines that extend out from the source of light. When a scene is created with backlighting, it is impossible to ignore the shadows since they advance menacingly toward the viewer, taking forms that are as important and interesting from the point of view of the composition as the figures that project them. In this exercise painted in oil, you will see how to combine both perspectives.

WITH BACKLIGHTING IT IS IMPOSSIBLE TO IGNORE SHADOWS

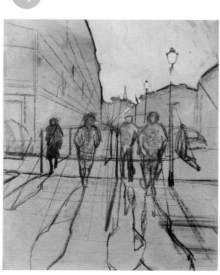

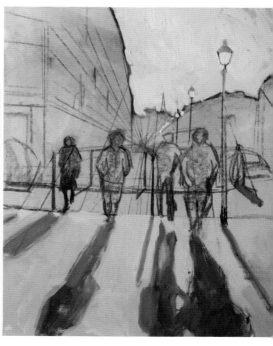

4. *The figures are strongly lit from behind, so their shadows grow in size as they advance toward the viewer. After you finish the sketch, cover the sky with a layer of white oil paint.*

5. *Paint the shadows very loosely, like sketches, with a mixture of cobalt blue and umber. Lighten the ground with a mixture of white with a little umber to make the forms stand out.*

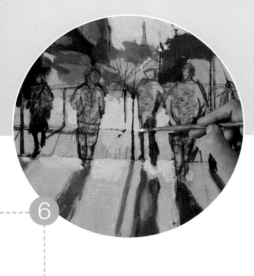

6. *Begin filling in the spaces in the background with dabs of gray violet. The strokes should very loosely suggest the architecture and silhouettes of the buildings that flank the street.*

7. *Paint the figures as seen when lit from behind. The highlights are added on the outlines, forming a luminous halo around some parts of the figures.*

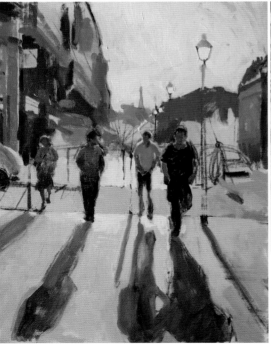

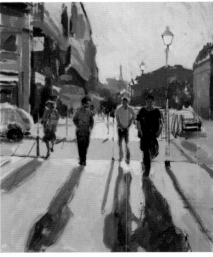

8. *The trees in the background are simply indicated with a few brushstrokes that combine three or four different tones of green. It is best if the farther areas have little detail, as if they were naturally unfocused.*

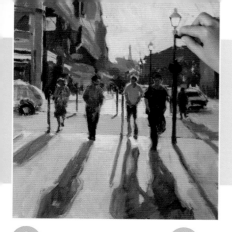

9. The cars are simply painted with a few brushstrokes and little contrast, while the upper parts of the streetlights are finished with lines drawn with a stick of charcoal.

10. Also use the stick of charcoal to emphasize the street by suggesting the cobblestones. Finally, apply some touches of light on the figures and finish the façades of the buildings with diagonal brushstrokes.

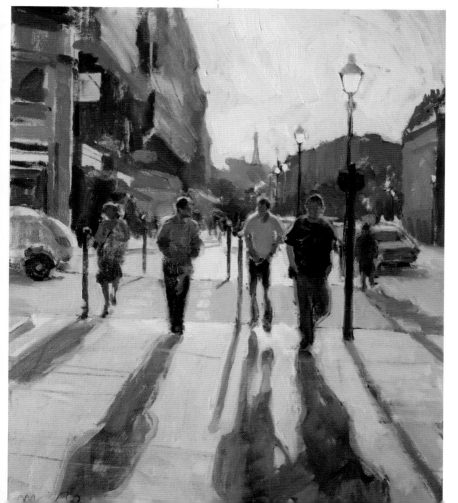

LET'S EXPERIMENT

A Bridge **in Perspective**

We will use a real model, a bridge with a few arches and a background replete with interesting façades.

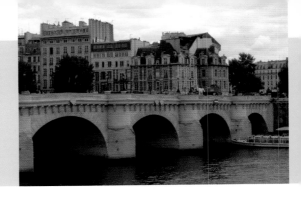

1. Use extra paper to enlarge the support to extend the lines of perspective from the bridge until they converge at a vanishing point located outside of the drawing.

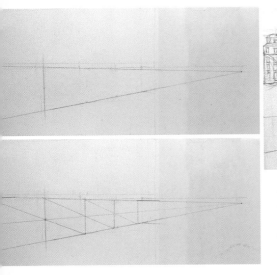

2. Indicate the width of the first arch of the bridge. To do this, draw a diagonal line from the very top of the first vertical line, passing through the center of the second and stopping at the lower line of perspective. This point marks the size of the second arch. Repeat this operation until completing all the distances.

3. After you have figured out the distances for each one of the arches of the bridge, sketch the façades of the buildings in the background.

In urban environments you find architectural elements with elliptical curves that require a careful drawing when you must reduce the sizes as they recede into the distance. One example of this is bridges. In the following exercise, you will calculate the distances of the arches of a bridge to achieve a representation that is well proportioned and has correct perspective. Here the main challenge resides in constructing the gradient that progressively reduces the sizes of the arches and reduces the space between them.

4. *Inside each trapezoidal shape that gives the bridge perspective, draw the arches while paying close attention to their elliptical shapes.*

5. *When the drawing is finished, paint it. The sky will be a good starting point. Cover it with a mixture of cobalt blue, white, and a tiny bit of carmine—just enough to make the color slightly gray.*

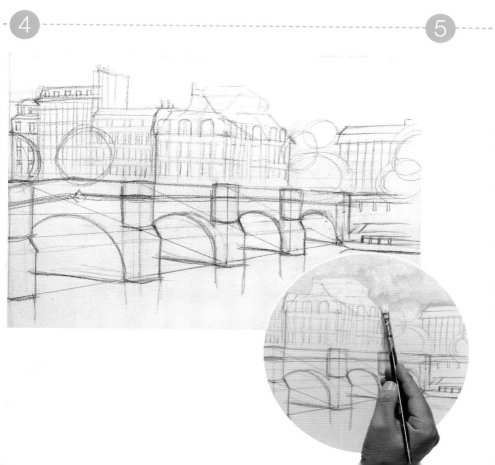

6. The façades should be indicated very loosely; there is no need to be very detailed. Work from top to bottom, painting the rooftops first and leaving open the spaces to be occupied by the windows.

7. The bridge is painted with stylized brushstrokes, just two tones of gray to build up the walls and black mixed with burnt umber for underneath the arches. Mix a green from blue and yellow, and add some bright green from a tube and some violet to sketch in the water.

8. The brushstrokes indicating the flowing water should all go in the same diagonal direction. The lightest reflections in the water should be blended with the darkest areas.

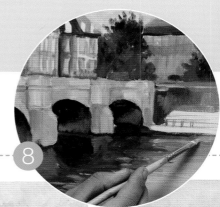

⑥ ⑦ — — — — — — — ⑧

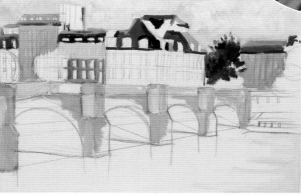

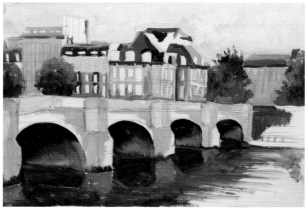

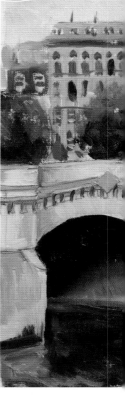

9. Strengthen the architectural lines of the bridge by making lines with a water-soluble colored pencil. Use the same color to add some ornamental details underneath the cornice.

10. Finally, finish the façades of the buildings along the river. As you can see, they are loosely painted, like a sketch with few attempts at detail. The buildings should be suggested, unlike the bridge, which should be a very solid image.

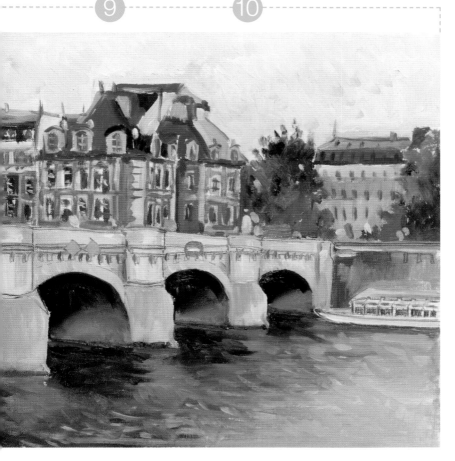

Freehand Perspective **for Painters**

When painting outdoors, artists usually cannot use rulers or straightedges for laying out the perspective of an urban scene, so they must use intuitive perspective—that is, working freehand and making quick measurements by eye. The result, of course, is not as precise as that of a work laid out with perspective lines in the studio, but despite the possible small involuntary errors, you must make sure that the buildings more or less coincide with the diagonal lines of perspective and make it look generally convincing.

When the lines of perspective are outside of the picture plane, make the same number of divisions on the three visible corners of the building, and join them to create the angles needed to represent the doors and windows.

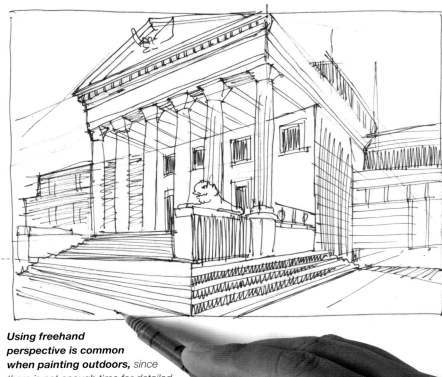

Using freehand perspective is common when painting outdoors, since there is not enough time for detailed measurements. The angles of the diagonal lines are measured by eye.

Simplifying the Rules of Perspective

When artists paint outdoors, what they are really interested in is finishing the drawing quickly because they do not have much time. They tend to simplify the perspective so they do not spend a lot of time on the drawing. They omit the horizon line and focus on drawing the angles of the façades by eye as accurately as possible. To make the perspective lines more or less accurate, they use the edges of the support, which are generally straight, as a reference and try to calculate the angle of each line of perspective. No matter how much they try, it is difficult to achieve an exact representation, but the goal of freehand perspective is to be minimally convincing.

Some Techniques

When the vanishing points are outside of the picture plane, one way of simplifying the perspective is to make the same number of divisions in the vertical lines that are on each side of the building. Divide them into equal segments and then join them with lines drawn freehand. To be coherent with freehand perspective, keep one basic principle in mind: the lines must converge at a single point so that all the lines of perspective are angled in a radial pattern, as if it were a fan. This can be very useful when you are drawing doors and windows on a façade. When it comes to the vertical lines in the drawing, they should be perpendicular and parallel to each other so they do not make the drawing more complicated.

Before starting the drawing, *artists usually make a more-or-less accurate preliminary sketch to help organize the urban space and make the streets line up with some lines of perspective.*

To make calculating the angles of the lines of perspective easier, *it will be helpful to understand that the lines of the train track and the façades of the buildings converge toward a single point in the background; and they radiate from that point like a fan.*

An **Irrational** Perspective

In this section we approach the subject by rendering the urban landscape, applying a method that is anarchical. It is based on creating a space using perspective, but it is applied in a very loose and imprecise manner. The space that is created is completely imaginary and can only be used for a more contemporary kind of painting, where spontaneity and visual instability are the main goals.

The use of irrational perspective can be seen in this cityscape that has an uncommon point of view and is strongly distorted.

This group of houses has a very forced and irrational perspective, which directs the viewer's eye toward a single vanishing point on the horizon.

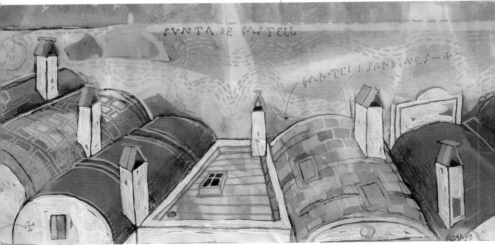

Perspective as a Dynamic Tool

Many artists have a certain sense of perspective, but they deliberately alter it, transforming its logic, stability, and order to convert the perspective into an obsessive group of horizontal and diagonal lines that give the painting a very dynamic appearance. This can be categorized as irrational perspective, which is more focused on expression rather than description, a mobile perspective that divides the space into changing geometric planes and allows you to represent different aspects of the same model at the same time.

Perspective at the Service of Expression

After looking at these cityscapes, the viewer can identify an order in the perspective of the scene; however, the lines of perspective are unstable, and although they act as indicators of height and depth, they seem somewhat perturbed by the expressive effects that they cause. Most of the buildings have their own slightly distorted perspective, which isolates them from each other and gives them a life of their own. Putting them all together in the same work of art produces a discordant perspective that is perturbed and irrational, and with a disquieting sense of confusion.

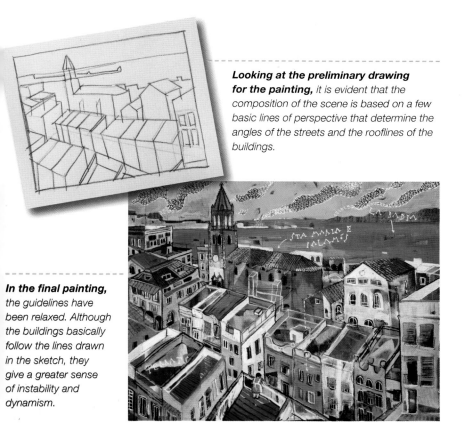

Looking at the preliminary drawing for the painting, it is evident that the composition of the scene is based on a few basic lines of perspective that determine the angles of the streets and the rooflines of the buildings.

In the final painting, the guidelines have been relaxed. Although the buildings basically follow the lines drawn in the sketch, they give a greater sense of instability and dynamism.

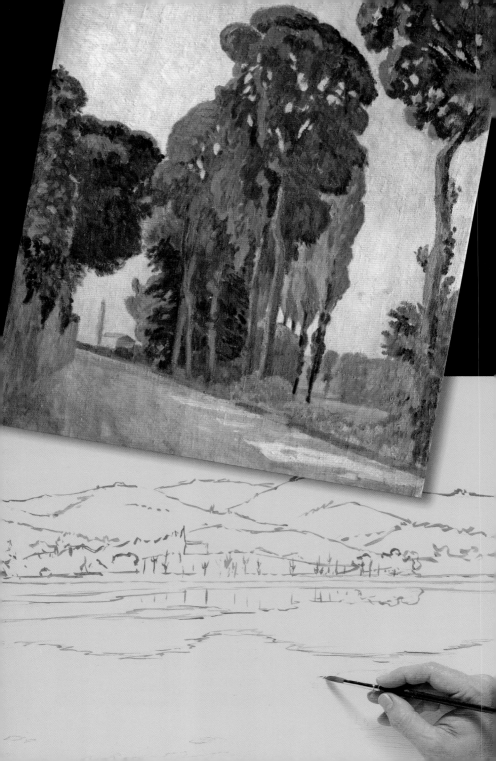

Landscape:
The Other Perspective

Linear, or geometric, perspective is a drawing technique that allows you to suggest the effect of distance and depth in any urban environment, but it loses effectiveness when the buildings, streets, and plazas give way to the natural landscape consisting of fields, forests, and mountains. Here, linear perspective is abandoned in favor of careful compositional techniques, atmospheric perspective, and other approaches that create the effect of depth in a natural environment. Color becomes the main means of organizing space and distinguishing the nearer places from the farther ones. The order and the intensity of the colors act as screens that contribute to the perception of depth in the landscape.

Perspective in the Landscape

In a landscape, architectural elements play a minor role in the composition, so there is no need for using linear perspective. There are other techniques: climatic and atmospheric conditions, like smoke and fog, contribute a sense of depth because the colors and tones of the image become softer and less contrasting as they get farther away. Gradations can also be used to increase this effect, creating a scale of colors and adjusting the brushstrokes as they move toward the background of the painting.

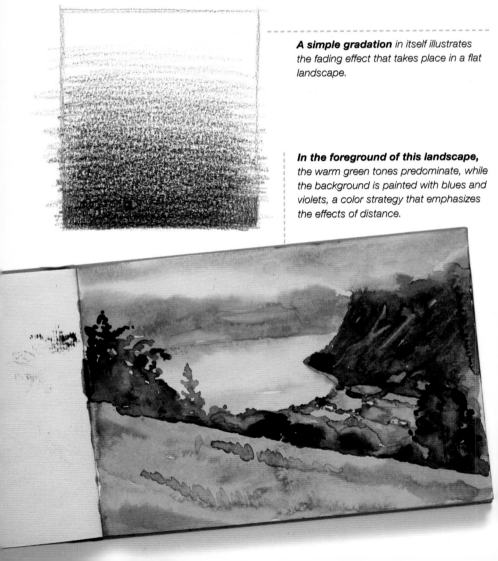

A simple gradation in itself illustrates the fading effect that takes place in a flat landscape.

In the foreground of this landscape, the warm green tones predominate, while the background is painted with blues and violets, a color strategy that emphasizes the effects of distance.

Value and Color Scales

The values and tones that you see in the landscape are clearly different from each other if you compare the foreground with the farther planes. The nearest tones are always more intense, saturated, and contrasting, and they seem to have less color and intensity as they move into the distance. The fading of colors in the landscape should be applied as if you were creating a value scale that becomes lighter with distance. Each plane should be seen as a theatrical backdrop dominated by an evenly shaded tone. Something similar happens with colors. In the nearest planes, the landscape tends to have warm colors, the middle ground is dominated by greens and earth tones, and the farthest planes tend to have blues and violets.

Lines of Depth

The effect of depth in a landscape increases when the vegetation and geographical features coincide with some imaginary lines that converge in the center of the paper, moving away from the edges of the painting. Adapting the composition of the landscape to these lines psychologically transmits a feeling of moving away to the viewer. The effect is even greater if the lines or brushstrokes used to construct the landscape have a radial orientation— that is, if they follow the same direction as the lines of depth; thus, all the colors will appear to be organized in a radial manner, around a central point.

Tones lose their intensity as they move away from the foreground.

This orderly succession of the colors in the landscape will emphasize the feeling of depth.

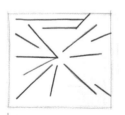

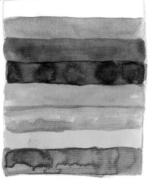

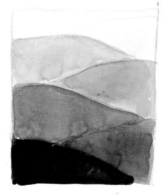

Lines of depth are imaginary lines that converge in the center of the painting. They are useful tools for composing a landscape.

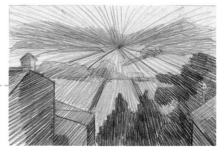

Radial strokes follow the same direction as the lines of depth and attempt to create a false impression of linear perspective in the landscape.

Atmospheric Perspective

When you are painting a natural landscape, linear perspective does not work because there are no architectural elements that act as a reference for drawing the lines of perspective. Therefore, the color, the light, and the effects of the brushstrokes fulfill the crucial role of communicating the perception of distance. Many artists imitate these natural effects in their paintings, using weak and pale tones in the planes nearest the horizon.

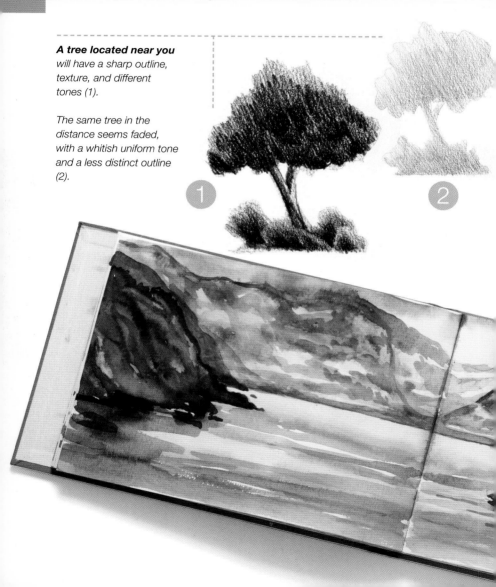

A tree located near you will have a sharp outline, texture, and different tones (1).

The same tree in the distance seems faded, with a whitish uniform tone and a less distinct outline (2).

The Action of the Atmosphere

When you look at a large landscape, it is easy to know which trees and mountains are near and which are farther away. There is a gradient of size—that is, those that are farther away are smaller, have bases that spring from higher ground, and are less defined. The fading of the colors of the farthest planes is produced by the action of the atmosphere, because between the observer and the object there is a thicker layer of air that is full of suspended particles of water and dust, which hinder the passage of light and the perception of the warm color ranges. Therefore, the farther away the plane, the lighter it is, and it has a greater tendency toward blue and even violet because blue is the color that best passes through the dense atmosphere.

A Suggestive Landscape

The farther away the landscape, the more vague it looks, with less detail. The colors are less intense and more faint and blurry. In atmospheric perspective, the atmosphere becomes watery, the colors dissolve, and the representation becomes more suggested and less distinct. As the landscape recedes, its colors change from browns, greens, and ochres to light blue. Distance is suggested by the absence of the object that is represented, a line of trees that are blurred, or the outline of mountains that can barely be distinguished from the color of the sky.

In the distance, the trees are blurred by the white mist in an atmosphere charged with humidity. The ones in the foreground are well defined and have more contrast.

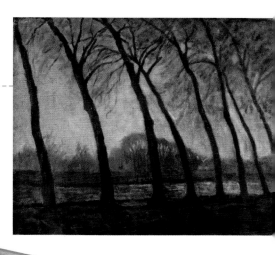

The background of a landscape is very blue because the farther away it is, the thicker the layer of air. Although sea air is transparent, its charge of humidity and dirt (fog and dust) make it difficult for light to pass through.

Camille Pissarro
(1830–1903)

Pissarro was one of the founders of Impressionism and, along with Claude Monet and Alfred Sisley, is considered to be one of the artists that best

Pissarro's personality was one of the most attractive of all the French Impressionists.

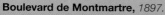

Boulevard de Montmartre, *1897.*
Pissarro painted numerous views of avenues and boulevards, captured from an elevated position that gives a view of the street with a sensational perspective. In this way he created a large space, with very clear lines of perspective that meet at a single vanishing point at the end of the street. His brushstrokes were quick and barely paid attention to the drawing, and there are a number of colors that create an atmospheric representation, which blurs the perspective lines. The overlaid brushstrokes fill the boulevard with pedestrians and carriages, creating an attractive effect of urban movement. In this work, Pissarro demonstrates that the effects of lights and atmosphere are his main interest, much like his contemporary Monet.

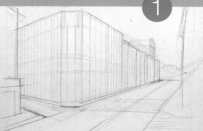

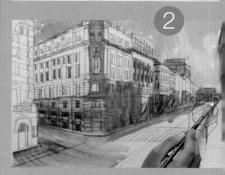

1. Here, we will paint a view of an avenue using Pissarro's method. First construct the perspective and the places occupied by the façades of the buildings in pencil.

2. Over this structure draw the main architectural elements on the façades. Then use diluted gray blue oil paint to cover the areas that are in shade.

understood and most purely used the style of atmospheric perspective.

Like the other Impressionists, he became interested in representing urban scenes at different times of the day. The image was always similar, but the atmospheric effects and the light changed, as did the flow of pedestrians. Pissarro's brushstroke was nervous, almost Pointillist, and his paintings of cities combined a well-studied perspective with an atmospheric treatment of the paint that accurately re-created the frenetic life of the Parisian streets, lined with elegant buildings.

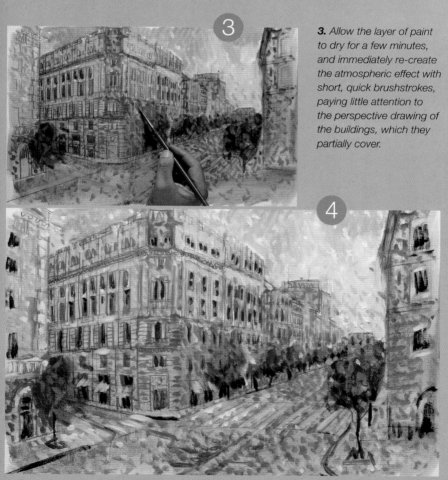

3. Allow the layer of paint to dry for a few minutes, and immediately re-create the atmospheric effect with short, quick brushstrokes, paying little attention to the perspective drawing of the buildings, which they partially cover.

4. The result joins the linear drawing of the buildings that line the street with the use of atmospheric perspective, which is more typical of a natural landscape.

The Perspective of Reflections

Reflections are an unavoidable aspect in the representation of landscapes that have an area of water. You can produce a reflected image of an object that is located above the surface or alongside a body of water that is calm and quiet.

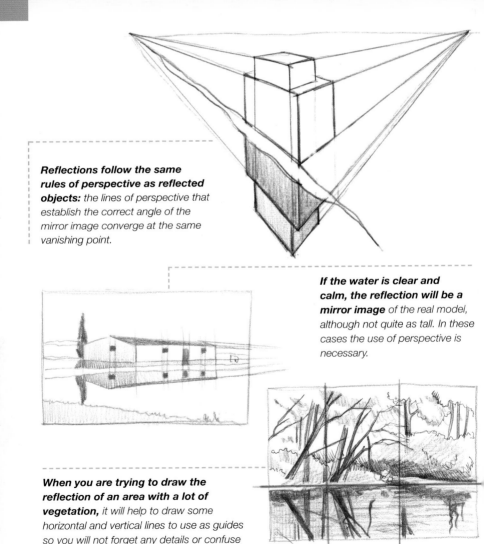

Reflections follow the same rules of perspective as reflected objects: the lines of perspective that establish the correct angle of the mirror image converge at the same vanishing point.

If the water is clear and calm, the reflection will be a mirror image of the real model, although not quite as tall. In these cases the use of perspective is necessary.

When you are trying to draw the reflection of an area with a lot of vegetation, it will help to draw some horizontal and vertical lines to use as guides so you will not forget any details or confuse some of the angles.

Reflections of Geometric Forms

The guidelines for rendering reflections on water are the same as those for explaining the image of an object reflected in a mirror. Therefore, the reflected image of an object is always inverted. The images that are reflected have the same vanishing point as the original ones, but the lines of perspective of the reflections have a smaller angle than those of the objects that are reflected. The reflected image looks shorter or squatter than the original. Although the reflections seem distorted by the movement of the water, you just have to squint your eyes to see that the reflected shape follows the rules of perspective that we have described. Finally, the ripples and slight waves become very important, and they can be an excellent way of enlivening the composition.

Reflections of a Natural Model

Reflections on a surface of calm water are an exact inversion of the real shapes, but their colors are slightly dulled. A scene from nature that is reflected on the calm waters of a river or a pond can be rendered by drawing straight vertical lines, which allows you to establish some parameters that will keep the viewer from becoming confused by the reflected image. From the most visible trunks and branches, draw several straight vertical lines to transmit the edges of the objects to the surface of the water. Using these lines, draw the reflections; the reflected images, besides being completely inverted, will always be a shade darker and a little less intense than the real model.

The reflection of an image on a pond or river will always be less defined and darker than the real model, to the point that it can be perceived as a kind of shadow.

Some pencil lines that are still visible in this watercolor were used to locate the reflection of the cloud in the upper half on the surface of the water. Notice how the lines of the composition converge on a single vanishing point in the center of the image.

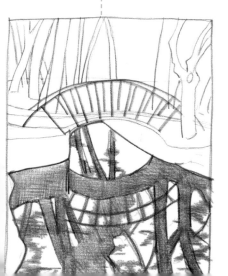

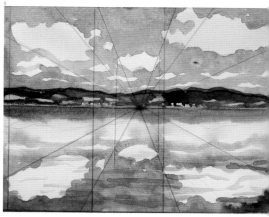

Directing **the Eye**

It is important to use some compositional techniques to create the effect of depth—for example, including rivers and roads that move into the landscape. Telephone poles, rows of trees, and highways create an opening in the landscape that guides the eye from the foreground to the background of the painting. Often, these means become the only linear element able to transmit the feeling of diminishing sizes and the converging lines of perspective.

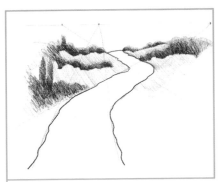

When the drawing of a road crossing a landscape becomes complicated, it can be constructed with vanishing points that indicate the changes in direction of each stretch.

After blocking in the vanishing points, their lines will give way to a heavier, darker line.

The valley and the trees that line the road help explain the depth and changes in elevation of the terrain.

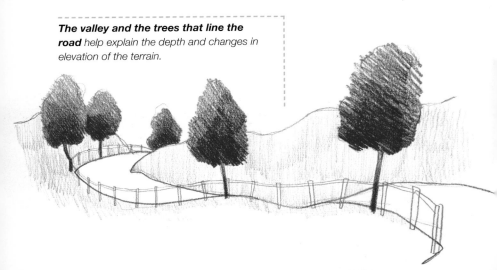

A Road in Perspective

Some believe that when you draw a road, it is not necessary to use perspective since it is sufficient to make a more-or-less accurate zigzag drawing. Here, we will show you how to represent such a road correctly. There is no doubt that this will be very useful advice for less experienced artists. It shows how to draw a highway with curves that disappear behind a hill. To make it easier, we will assume that both sides of the road are parallel to each other and that its width is more or less consistent. First draw the horizon line and on it draw as many vanishing points as there are segments or stretches of road. After each curve the road has a new vanishing point. You will draw the definitive road over the various converging lines of perspective.

Indicators of Distance in the Landscape

A river is a water highway that quietly flows, or does not, through a valley or a plain. It gets narrow far away and wider as it advances toward the viewer. Just like the roads and trails that cross the landscape, it can be lined with trees, fences, and posts, so that besides directing the eye into the distance, it incorporated a reference represented by the progressively diminishing sizes of the vertical elements. Another technique that helps relay the idea of distance is explaining, through slopes and changes in the road's gradient, the irregularities and the relief of the terrain. This can be done by raising the horizon line when the road is going up, and lowering it when it moves downward.

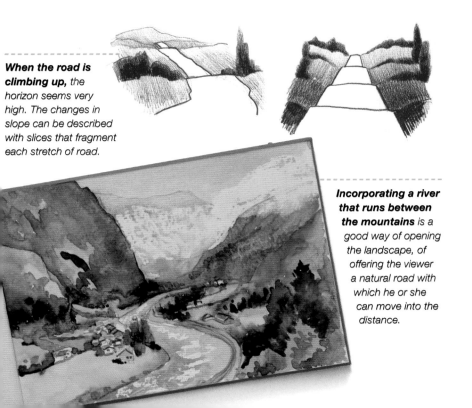

When the road is climbing up, the horizon seems very high. The changes in slope can be described with slices that fragment each stretch of road.

Incorporating a river that runs between the mountains is a good way of opening the landscape, of offering the viewer a natural road with which he or she can move into the distance.

Graphic Techniques for **Showing Depth**

Certain formulas for composition help emphasize the perspective effects to create greater depth in the landscape. Thus, the inclusion of diagonals, the incorporation of roads that move into the landscape, reinforce the effects of depth in a scene. Here, we will take a look at some of these techniques.

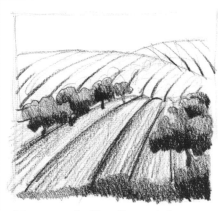

A foreground with a diagonal shape *helps to project the terrain toward the background of the landscape.*

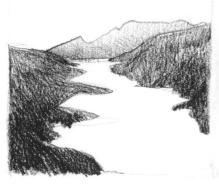

The basin of a river opens the landscape *and leaves ample space so the viewer's eye can look far into the distance.*

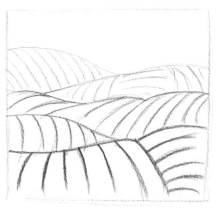

You can change the directions of the plots of land *that have been plowed and arrange them diagonally to suggest more depth in the scene.*

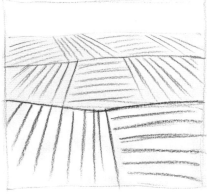

This system can even be used on flat landscapes, *as long as you make sure that you make darker lines in the nearest fields.*

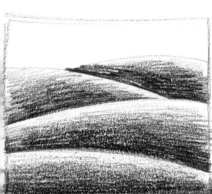

You can use a stage set technique to represent the depth of mountains with a succession of gradated shapes rather than progressively making them lighter.

An area that is left unpainted or even out of focus in the foreground can be a way to emphasize the depth of the scene.

When the background of the landscape looks atmospheric and blurred, including a contrasting object (in this case, a tree in the foreground) will highlight the effect of depth.

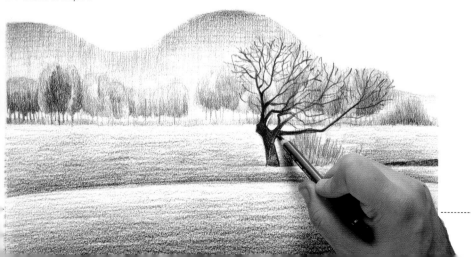

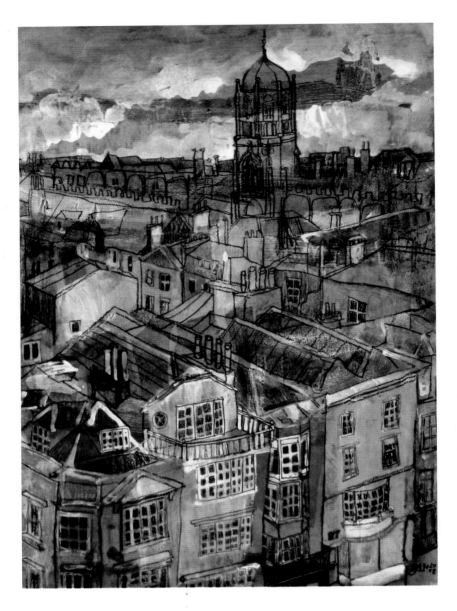

"*A street is not made up of tonal values, but is something that bombards us with sizzling rows of windows and humming beams of light dancing amidst vehicles of all kinds, a thousand undulating globes, the shreds and fragments of individuals, the signboards, the roaring tumult of amorphous masses of color.*"

L. Meidner. In A. González and others:
***Escritos de Arte de Vanguardia* 1990/1945**